From an essay on clothing
by Will McBride.

the Photo Essay: Paul Fusco & Will McBride

text by Tom Moran
with the editors of Alskog, Inc.

An Alskog Book
published with

Thames and Hudson • London

Photographs copyright © 1974 by Paul Fusco
Photographs copyrighted © 1974 by Will McBride
Photographs previously copyrighted by Paul Fusco
Photographs previously copyrighted by Will McBride
Text copyright © 1974 by Tom Moran and Alskog, Inc.
Technical section text copyright © 1974 Vincent Tajiri

Thames and Hudson, Ltd.
30-34 Bloomsbury Street, London WC1B

ISBN: 0 500 54026 8
First Printing
Printed in the United States of America

A Balinese father about to
bury his child, from a Look
essay on Southeast Asia by
Paul Fusco.

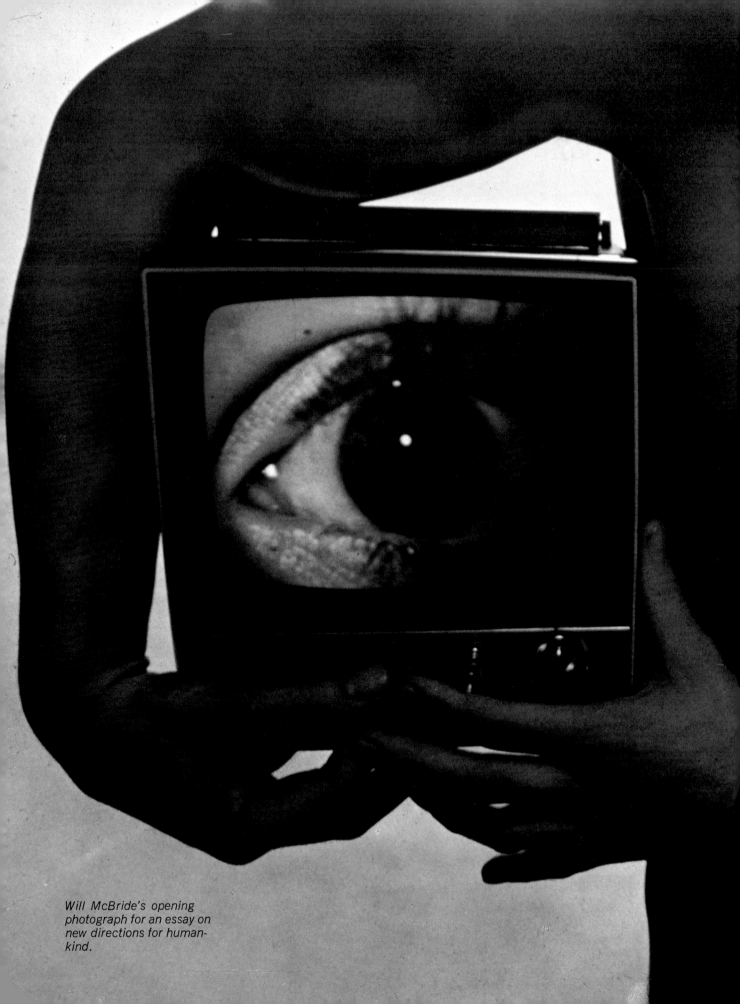

Will McBride's opening photograph for an essay on new directions for human-kind.

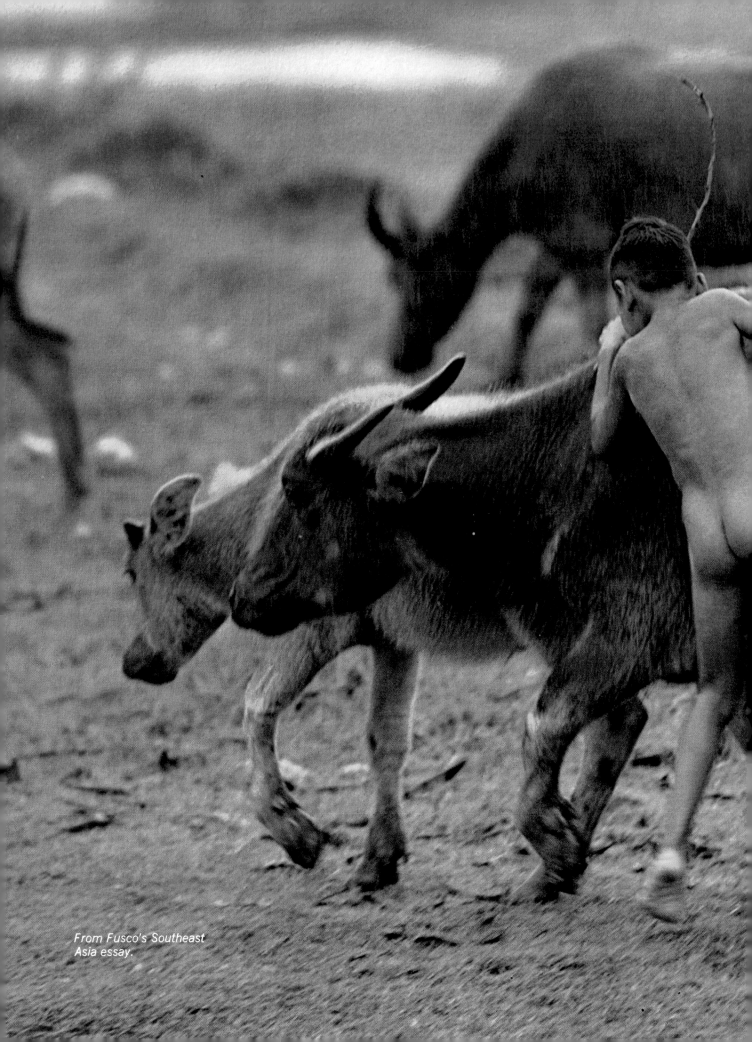

From Fusco's Southeast
Asia essay.

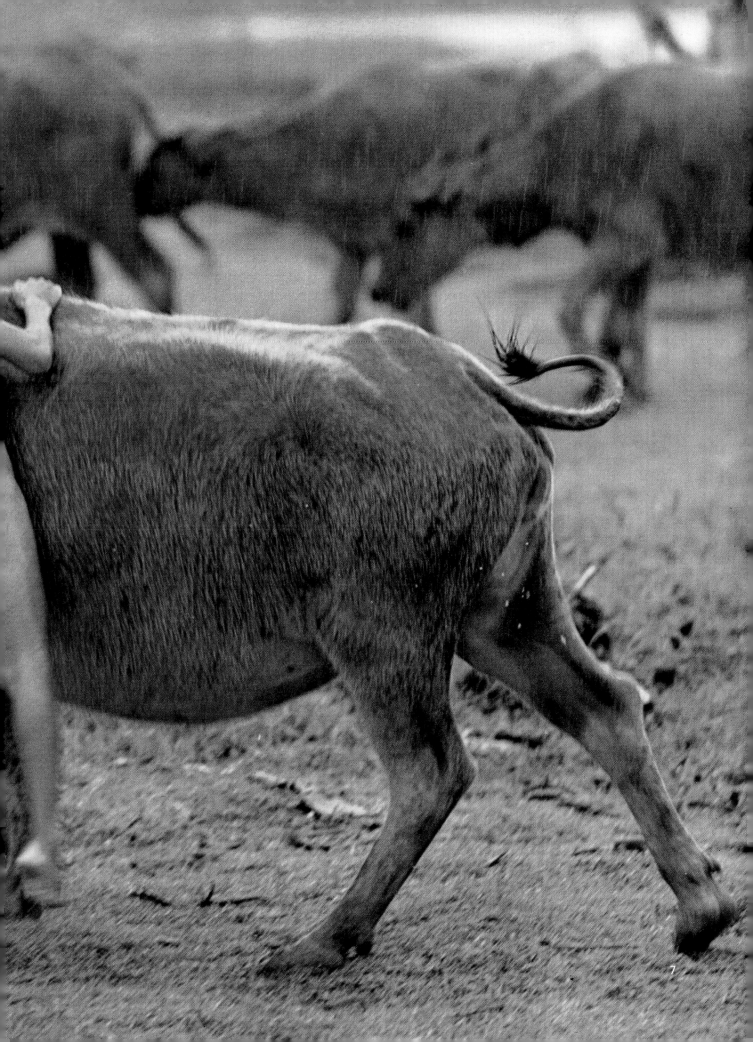

Introduction

An essay is one of the most personal and powerful forms of narration a photographer can use. Its series of images, telling a story along straightforward literary lines or resonating with each other to develop a theme in freer form, offers a visual adventure that is at once deep and broad.

People meet photographs every day as illustration, journalism, portraits, studies of the human figure in action, personal statements by well-known professionals. We see more photo essays in a day than we realize, in company slide presentations, TV commercials, and of course in magazines. The ordinary family photo album need not be what a famous essayist recently described to us as a "parking lot" of snapshots; instead, a summer vacation or a birthday party could be presented as a rich, rounded experience.

As the most contemporary of photographic forms, the essay is also the most controversial. What, exactly, *is* a photo essay? There was not much argument over definitions as the form matured during the 1930s and 1940s in the hands of pioneers such as Margaret Bourke-White, Leonard McCombe and W. Eugene Smith, who seems to have been the first to use the word "essay" to describe it. But now, in its second and third generations,

there are probably as many definitions as there are photographers. Smith, author of not only the name but of the classic examples of one type of essay, leaves no doubt in this book about his own unyielding standard. There are those who will disagree with him. Amid the arguments, the photo essay is thriving in the hands of photographers such as Paul Fusco and Will McBride.

Fusco and McBride are poles apart as personalities and as story tellers, but both are photo essayists who repeatedly test new approaches and refine older ones. Fusco's concern for the real joys and problems of the people he photographs emerges through a working style that is basically exploration. He finds people he wants to photograph—farm workers, his children, Appalachian miners—and enters the flow of their lives, letting the truth, as he sees it, unfold before his camera.

McBride, on the other hand, works more like a film director. Often casting actors in his essays, he constructs a series of images worked out in advance. The essence of his work is fantasy; the intent is to persuade a viewer to try some course of action—to follow Hermann Hesse's Siddhartha or Europe's young vagabonds into a new way to live—and the main ingredient is a meticulous arrangement of beauty.

This book, itself an essay on essayists, owes much of its depth to the generous help of photographers including W. Eugene Smith and Bill Pierce; art directors including Allen Hurlburt and Will Hopkins; picture editors including John Durniak, Dick Pollard, and Charles Reynolds; and of course, Paul Fusco and Will McBride.

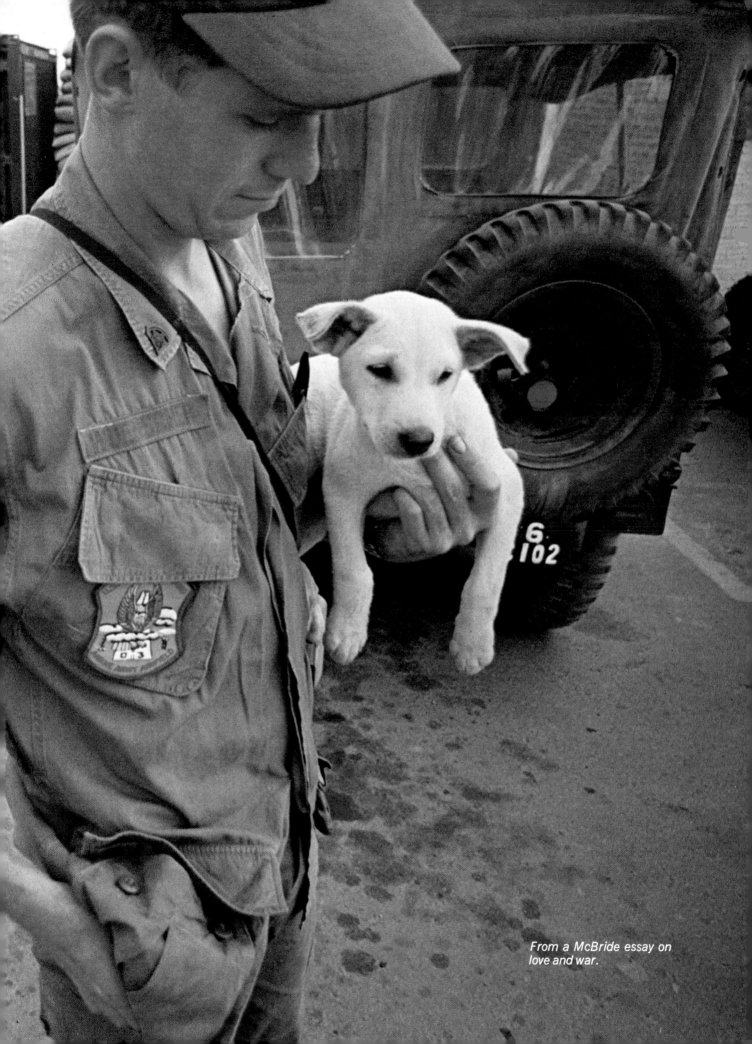

From a *McBride* essay on
love and war.

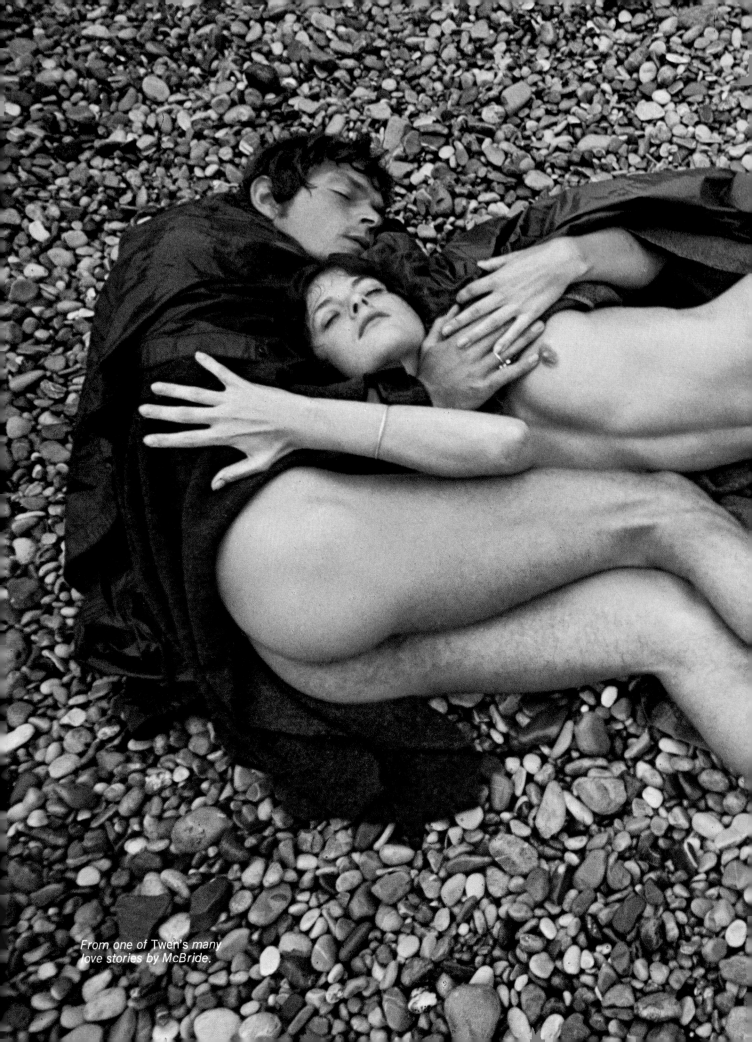

From one of Twen's many love stories by McBride.

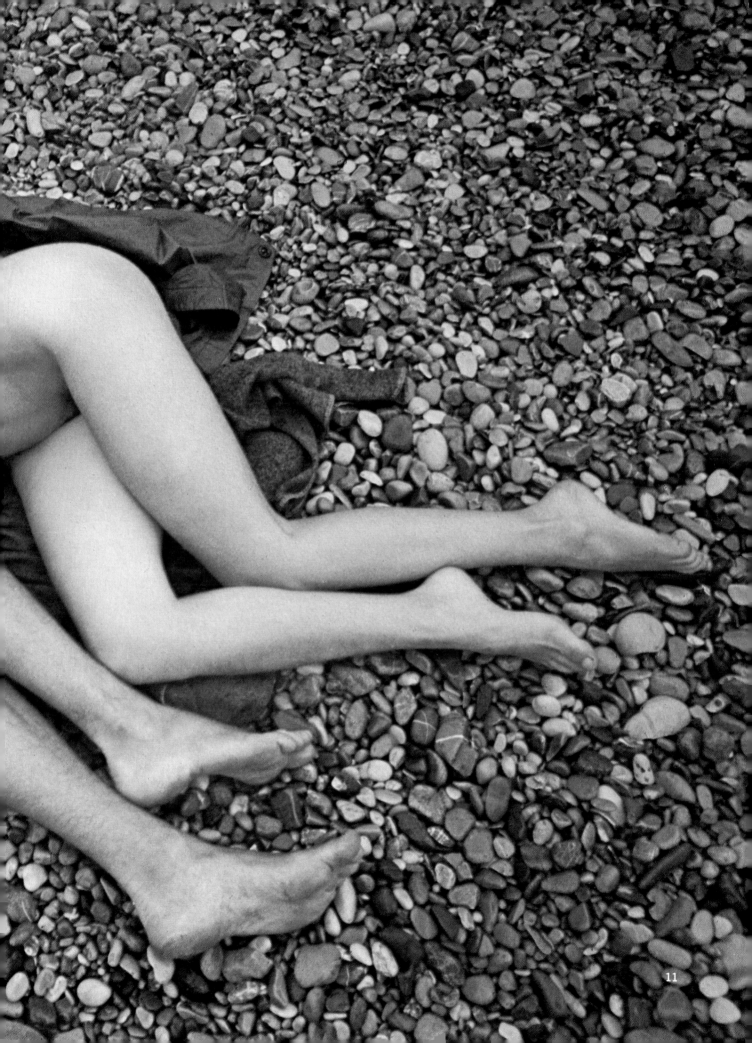

Watching it happen, making it happen

Paul Fusco could hear the women's voices in the small kitchen of the cabin. For three weeks he had been studying this family in Kentucky with his cameras, asking only that they let him blend silently with their rhythms. He talked when they felt like talking, but mostly he watched, calculating relationships, fitting together images for a photo essay on the texture of a life he was beginning to understand. His presence was muted, for he wanted to show them as they had been before he came.

"There he is," Fusco heard the younger woman say. He glanced through the window to a stoop-shouldered figure on the road below, and paused for a decision. He had been looking for some way to dramatize the strength of these people who worked appallingly hard for rewards that included poverty and black-lung disease. The tired young miner come to pick up his wife, face streaked with coal dust,

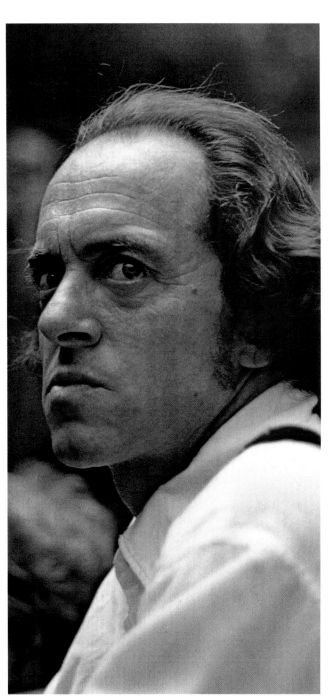

boots scuffing the gravel as he waited for her to emerge from her mother's cabin, mirrored some of that strength.

There was little time. Fusco knew he could rush out the back door and circle the house to get closer to the miner before his wife joined him. But such a move would probably alter the emotional tone of the man's stance. He would react to the cameras, and Fusco

would have destroyed a moment he was trying to preserve. Instead, he decided to get it while it lasted, with a telephoto lens. Fusco's guide was his own experience, his reference point the work of other photographers who had brought images of truth out of similar situations: W. Eugene Smith, Leonard McCombe, Mark Kauffman, Grey Villet, to name only a few. He stepped quietly from the warmth of the cabin to the chill air of the front porch, adjusting the aperture of his 180mm lens as he moved. He had been carrying four cameras, each fitted with a different type of lens, for flexibility in just such moments. As he focused the telephoto and tripped the shutter repeatedly through an entire roll of film, the miner neither saw nor heard him, and certainly did not imagine that the picture on pages 40-41 would become a central image in an essay on George's Branch, Kentucky, or that his face would come to symbolize the suffering of Appalachia.

Paul Fusco's picture stories and essays appeared regularly in *Look* magazine for 14 years. Each studied some facet of our time and our world, representing the photographer's personal discoveries within it. The most important of them portrayed Fusco's explorations into possibilities for the future, the roads to change that he hoped might enhance all of our lives. Since 1971, when *Look* ceased publication, Fusco has continued to share his perceptions

both in books and in every major periodical that uses photographs. His work schedule borders on obsession; the competitive spirit that flogs him toward excellence has brought awards and honors from art directors, museums and photographic societies, yet his keenest pleasure comes from knowing he has taken a picture like the one of the Kentucky miner.

"What I want to do," he says, "is move people as deeply as I can on as many levels as photography can."

To the people in **Will McBride's studio in Munich it all seemed so ridiculous,** so trivial. No matter how long they had known this photographer, the haggard assistants, actors and hangers-on doubted they would ever understand. Work on a single picture had been lurching along for most of a day, starting and stopping at McBride's whim. This time it had stopped when he flung down a handful of leaves they had brought him, announced that if nobody in the room could find one the color and shape he wanted he'd do it himself, and ran out the door. Beneath the high ceiling of the white studio, they stood with heads droop-

ing, counting the seconds until his return.

The door banged open. McBride strode in on long, skinny legs, clutching a handful of freshly plucked green leaves.

"Let's go! Everyone!"

he bellowed, and suddenly the place came awake. He jabbed a finger at an assistant browsing through layouts of a new sex book for children. "Put those damn things down! We're done with

them. Take these." He thrust the leaves at the assistant. He dashed across the studio floor, a stream of oaths and orders rolling from his lips; as if in counterpoint to the hubbub, his large hands tenderly folded a male model's finger around one leaf. In seconds, everyone was in place.

Two models rested their arms on small tripods in front of a spunglass screen. McBride focused a 105mm lens. "Raise your hand a bit," he urged in a voice grown smooth and gentle now that he was behind his camera. "To the left. I like the leaf horizontal. Good. Perfect." He reached out to touch both hands affectionately, purposefully, moving the fingers into the pattern he wanted.

As he peered through the pentaprism of his camera he reached out blindly with his free hand. "Give me the syringe." Like a surgeon's nurse, an assistant clapped it into McBride's palm. He stretched over the camera, held the syringe to the leaf, and squeezed. A pair of shining droplets clung where he touched it.

A final check through the lens assured McBride that everything was blocked perfectly, and— at last—he pressed the shutter release. A burst of light from an electronic flash unit filtered through the spun-glass screen, simulating daylight. Nobody in the room dared to breathe as the shutter clicked and the strobe flashed again and again. At length McBride raised his head, grinned, and palmed away the per-

spiration about to run into his eyes.

"Great," he said, moving to embrace the models. "That was wonderful." Sighs of relief whispered through the studio. The photographer's own relief had to wait until later, when the film was processed and the image on page 52 found its way into print as part of an essay called "The New Man."

Unlike Paul Fusco, McBride does not aim to record the world as he finds it. He creates visions, just as he often fits a long-haired wig to his balding head — to improve on a reality that bothers him—and photographs the meeting of fantasy and reality with fanatical attention to design.

That is why a single leaf is so important. It cannot be just any leaf; it must match the one that already lives in McBride's inner vision.

Though they began in different disciplines — Fusco as a photojournalist, McBride as an illustrator — both are developing variations on the essay, most intricate of all the forms a photographer can use to communicate with a viewer.

Pictures in a photo essay can be orchestrated to explore a theme deeply in rounded detail. They do more than describe; they interpret, pulling some reaction from the viewer. By setting up resonances between pictures, a photographer can often transmit information — emotional, factual, idealistic — on several levels at once.

As you might expect of a form so sensitive to personal interpretation, the essay has provoked arguments since its earliest days and continues to do so. Should it be considered the photographer's show alone, or is it a collaboration between photographer, editor, writer, darkroom technician and printer? Does this group of photographs tell more about the world than that one? Is it, speaking strictly, an "essay" at all? The examples of work by Fusco and McBride in this book raise all these questions, and answer some.

The roots of the modern photo essay stretch back to an interview of chemist Marie Eugene Chevreul, conducted in 1886 and photographed by the French artist who called himself Nadar. *Le Journal Illustré* took advantage of a new printing breakthrough, the halftone, and published the first sequence of photographs of a single subject, captioning each picture with the chemist's words at the time of exposure.

Editors began clustering pictures to give readers a sense of being on the scene at wars, political debates and other exciting events. In the 1930s, German journalists, particularly the Hungarian-born editor Stefan Lorant, began using layouts that emphasized certain currents in the pictures — tension in the Reichstag, the pomposity of Mussolini's huge office. One offshoot was the picture story, with its strong beginning-to-middle-to-end narrative drive that described, say, a day in the life of an interesting personality. Another was the photo essay that still has a beginning, middle, and end, but serves more as a vehicle for the photographer's interpretation of some larger theme.

The power of the essay as a journalistic form emerged from two developments. First was the introduction in the early 1920s of lightweight cameras with fast lenses such as the Ermanox and the Leica that allowed photographers to freeze action or catch subjects off guard with an unobtrusive ease and speed that had been impossible with earlier equipment. Second was the debut of large-circulation picture magazines. *The Weekly Illustrated* and *Picture Post* hit their stride in England during the 1930s; *Life* appeared in the United States in November, 1936, and *Look* in January, 1937. They soon became the photo essayists' most spectacular showcases.

The lead feature in that first issue of *Life* was a series of photographs taken by Margaret Bourke-White in the boom towns near the construction site of Montana's Fort Peck Dam. The pictures told a clear and poignant story of the tough, dusty life people were living on this last Western frontier. The term "photo essay" was coined later by W. Eugene Smith, but Bourke-White's nine-page picture story on the Fort Peck migrants clearly showed the way toward the full-fledged essay.

Out of World War II came a generation of photographers who refined the form. Whether they stayed with a subject for weeks to bare the inner workings of an "ordinary" life, or roamed through a broader landscape, their visual discoveries began to reach and move a gigantic audience. Photographers were quick to recognize the power of the essay, to expand the awareness of their viewers, and their work began to take on a keenly personal flavor.

Differences in personality among the essayists injected variety and turbulence into the form. Leonard McCombe's warm, down-home portrayals of ordinary lives; Bill Eppridge's unblinking stare at people on the fringes of society; John Vachon's lyrical portraits of Ireland; W. Eugene Smith's passionate images of people as archetypes for all humanity—these were just some of the approaches the essay took as it matured.

To the zenith of this early collection of styles rose the work of Smith, a photographic genius whose interpretive essays — including studies of a country doctor, a Spanish village, a North Carolina nurse-midwife, and Albert Schweitzer, all published in *Life* between 1948 and 1954 — are regarded as classics of the form. It was Smith who took to using the word "essay" to describe what he was doing, and it is around Smith, still active and pugnacious in his middle fifties, that much argument over essayists such as Paul Fusco and Will McBride revolves.

At dinner with Smith on a recent evening, the editors of this book turned the conversation to definitions of the form he had helped to invent. His pronouncements, as always, were absolutely unyielding.

"A photo essayist," Smith declared, "is a photographer who manages to comprehend a subject — any subject, whether it's coal miners in Appalachia, or love, or mercury poisoning of human beings in Minamata — and gives a lot of thought to weaving the pictures into a coherent whole in which each picture has an interrelationship with the others.

"In my Schweitzer essay, for example, there's a picture of some goats standing on the roof of a building. It didn't show Schweitzer, but it did say something about the surroundings in which he lived and worked. On the other hand, a good essay-ist sometimes fights off the temptation to use a great, strong picture, because it might confuse rather than contribute to the theme. I am still trying to sell some of my best pictures. I removed them from the essays I shot them for; using them would have been like putting a strong speech in the first act and throwing the whole play off balance.

"But just having a long story doesn't make an essay. You can take a group of pictures all in the same place, on the same subject, and lay them out to make a powerful visual statement, but if they don't reinforce each other — if they don't show those interrelation-ships that make the whole more than the sum of its parts — you've got what I'd call a portfolio.

"That's okay, but I would not allow myself to call it an essay."

And Smith is ruthless about what he allows himself to honor with that name. "Mark Kauffman did an essay on Marine training camp in the early 1950s that nobody seems to have recognized for the masterpiece it is. On the other hand, Cartier-Bresson is more a port-folio-maker than an essayist; his true great-ness is that when you see one of his pictures you learn a great deal about people, but very little about *the* people in the picture. And I'd call most of the fine *Life* photogra-phers — of the caliber of Margaret Bourke-White and Alfred Eisenstaedt — wonderful photojournal-ists who did mostly picture stories, narrative

reporting. Again, that's a form of its own, not an essay.

"Now there is a really low category that mas-querades as an essay or portfolio but is obviously just thrown together — a parking lot of pictures."

There are journalistic essayists like Fusco and illustrative essayists like McBride, but as far as Smith is concerned there is no such thing as an objective essayist. Why? "Because there is no such thing as objectivity. To anybody who tries to tell me they just walk up and shoot what's in front of them, that they do not control what's in front of them, I say that they *do* control it. Otherwise, how do you explain what happens when a whole crowd of photographers keeps showing up to shoot pretty much the same thing and the same ones, over and over, get much better pictures than others? You control what you do on your end."

Control is paramount in McBride's pictures. Fusco, too, even at his most journalistic, chooses images with care. He knows precisely what his lenses and his film will do. He carries a notebook

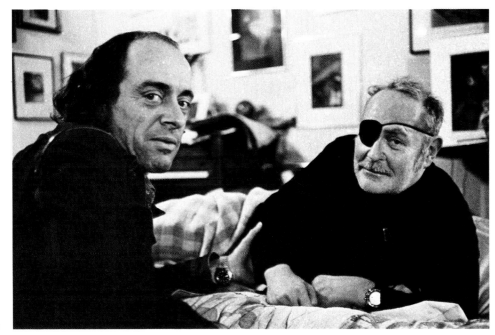

Paul Fusco (left) and Eugene Smith in May of 1974.

everywhere and makes notes, both written and mental, on the quality and direction of light in a spot to which he thinks a subject might return, on the colors of foliage, on features of weather and landscape that might affect the emotional tone of people in a picture. He has often returned over and over to a place at carefully calculated times, waiting for conditions to help him show what he feels about the place and the people in it.

"That," Gene Smith says, "is every bit as 'objective' as a picture by a guy who just walks up and says, 'Boom! I got my snapshot.'"

So much for individual pictures. What about the construction of an essay? Should a photographer lay it out himself? "Yes! Of course!" But doesn't the photographer run the risk of losing perspective by staying too close to the material? Shouldn't an essay be a collabora-tion, as most magazines have made it, with the photographer as the most important member of a team that includes an editor, a writer, and others? "No!" exclaims Smith, who quit *Life* twice

because he felt the organ-ization interfered with his layout ideas for his own essays. "I can stand back and see things with a cold eye once I've made the pictures. To say a photographer can't edit his own pictures is like saying that an editor of a magazine should let a stranger change it around at the last minute before it goes to press. Why not leave it to the one person who's an expert on the subject?"

Smith's flinty definitions are not every-one's. Paul Fusco and Will McBride can acknowl-edge the influence of masters who preceded them, while working out individual approaches to the essay that are as true for each of them as

15

Smith's is for himself.

This book, therefore, does not contain a series of neatly classified essays by Fusco and McBride. It examines their experiences with some of the problems that confront a photo essayist. How does a photographer use a series of images to explore an intellectual concept; a continuing news story; the victims of economic brutality; ideals for the present and future; a famous book; hedonism among the young; approaching old age?

Both men have worked closely and even happily with editors and art directors at magazines. Along the way, mingling their own impulses with those of their collaborators, both of them have leaned occasionally toward the kind of majestic essay that Smith and others perfected in what you might call the Classical Period of the 1940s and 1950s. Still, their work also branches into portfolios, portraits, but not many parking lots, on its way to the kind of personal observation that fits each photographer's own requirements for an essay.

Will McBride, for instance, might appear to be a salesman at heart, issuing commercials for sensuality and new ways of life from his base in Europe. His collections of pictures reflect the tight control he exercises, very much like a movie director, over their creation. By his choice of themes, he has clearly

separated himself from the American midwest where he was born in 1931. Though his early ambition was to write, a chance meeting with the illustrator Norman Rockwell led him to study the painstaking way Rockwell built up a story-telling painting. An ROTC commission took him to the Army, where he greeted the base duty officer outside Würzburg, Germany, by asking, "What do you have for me to do? I'm a painter and an artist." Assigned to work on the First Infantry Division yearbook, he began experimenting with cameras, and after his discharge in 1955 he vagabonded through Europe on a journey that is, in a way, still in progress. Despite a personal life that has been turbulent, to say the least, his association with the German magazine *Twen*

and its autocratic art director, Willy Fleckhaus, helped to broaden his perception from individual pictures to multiple images for essays and books.

McBride's work is more European than Fusco's in its pointed comparisons between old culture and new. It is often impersonal in setting and loaded with symbols. Allen Hurlburt, former art director of *Look,* senses "a cynical European cabaret attitude" in many of McBride's essays, which might come from McBride's penchant for communicating through situations he controls down to the last drop of water on a leaf. The portrait of Konrad Adenauer (pages 84-91), which began as an essay on old

Barbara McBride (above) and Will without his wig.

age, is the only work in which McBride has not isolated and created a world as he would like it to be.

Paul Fusco is less prone to recreate situations, though he will do so if it seems to help the flow of a theme. He approaches people in their own environment, trying to keep the viewer as aware as possible that the context of the pictures is real. If the pictures have an individuality and personality of their own, that is merely a signal that what you are seeing is Paul Fusco's truth, not Will McBride's or W. Eugene Smith's.

Fusco thinks like a novelist, searching for story lines and significant moments, trying to perceive form in the tangle of people's lives, concentrating on finding suitable opening and closing photographs, thinking of continuity for the inner body of the essay, calculating all the elements with a sense of purpose that is, for all his pleasant manner, quietly ferocious.

Weighing every move is not a practice Fusco turns on just when he is at work on a set of pictures. He spent his first 21 years in Leominster, Mass., without much idea of how to reach the world outside; for several years after high school he drove a truck, then made cement blocks, then worked in a plastics factory. In

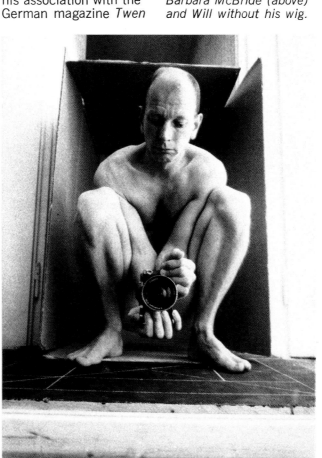

1951, however, he took the sort of calculated step that has characterized his growth ever since. He volunteered for the draft, looking two years ahead to the G.I. Bill benefits that would send him to any college he chose — if he lived through the Korean War. Toward the end of his tour, he swept several times a day over the Chinese lines in an L-19 reconnaissance plane to photograph troop positions, and the gratitude of the United Nations soldiers who used his pictures made it clear that the trade the Army had taught him could change someone else's life. "They were probably the most useful photographs I've ever taken," he recalls, "because they kept people from getting killed. Shot up. Deformed. I felt very good about being able to do something that actually helped someone in a very grave situation."

His calculation paid off, too, with the tuition aid he had wanted. For college he picked the photography department at Ohio University. Spotted in his junior year by picture editors from *Look,* he spent that summer and the next as an intern at the magazine's New York offices, sweeping the studio, moving lights, loading cameras, taking an occasional picture. Allen Hurlburt invited him to join the staff three months after graduation. A stroke of luck? Not quite. Fusco had arranged his college days as tightly scheduled, 18-hour marathons in which he drove himself as hard as he does now: "I wanted to make my mark in photojournalism. The only way I could do it was to work all the time, to learn as much as I could before I got out, so I could compete with the professionals who were already doing the work I wanted to do."

Paul Fusco: Expressing ideas through action

The January 13, 1970 issue of *Look* approached the decade of the Seventies as humankind's "last, best chance." Four opening pages were crowded with splinter-shaped, vertically distorted black-and-white photographs showing poverty, famine, war, disease and hatred as a reminder of the world's great fears and a warning that despair could overcome hope. As you turned the final page of this series of vertical, monochromatic horrors, the magazine opened to a single photograph sweeping horizontally across a two-page color spread. Instead of despair, this picture of a young girl sprinting through a landscape of mythic beauty prompted a surge of joy.

It was the beginning of Fusco's answer to a problem the editors of the issue had posed six months before: How can we make a reader *feel* what we mean when we talk about a re-awakening of hope? Fusco's job would be to produce a set of truly hopeful pictures that would give

Paul Fusco in 1974.

substance to the idea.

His involvement in such projects — as the essayist whose photographs could not only tie together broad themes but also give them a visceral immediacy—had expanded steadily in his years at *Look.* One reason was that he had grown accustomed to working closely with writers and art directors. The lone-wolf essayist, assembling some private vision and dumping it full-blown on an editor's desk, was never part of the atmosphere in which Fusco learned his trade. Photographers and writers studied, traveled, talked with each other to explore concepts that might grow into story ideas, and when a particular writer-photographer team found they produced good results, they found ways to work together often. "You generate a potent force," says one of those writers, George Leonard, who was *Look's* West Coast editorial manager, "when you take a talented individual and give him an institution to support him." While Fusco was sharpening techniques with which to question the behavior of the society around him—in essays on farm workers, miners, oppression in the cities, Southeast Asia and dozens of others—he felt that support.

Some members of the *Look* staff, led by Leonard, began focusing attention in the early 1960s on individuals and groups who were experimenting with ways to prove that every human being is capable of greatly expanded creativity, awareness, and joy. Between harsher projects, Fusco visited scientists, educators and philosophers, doing homework for essays to come. He took pictures but he also listened, filled notebooks with observations and questions, got

17

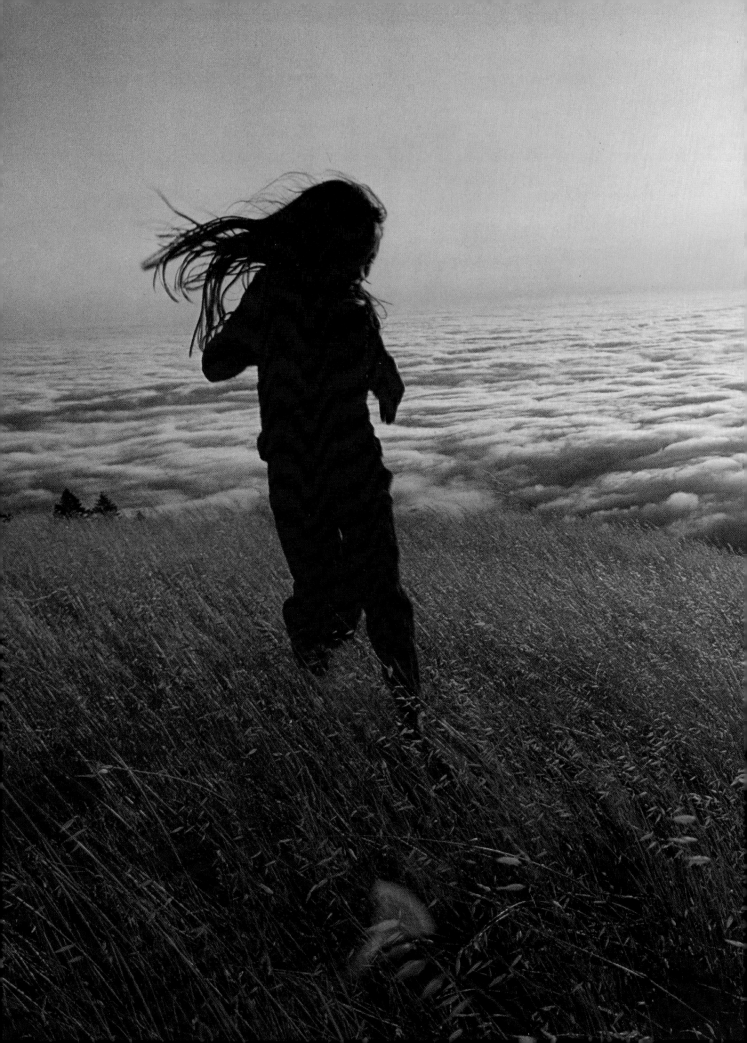

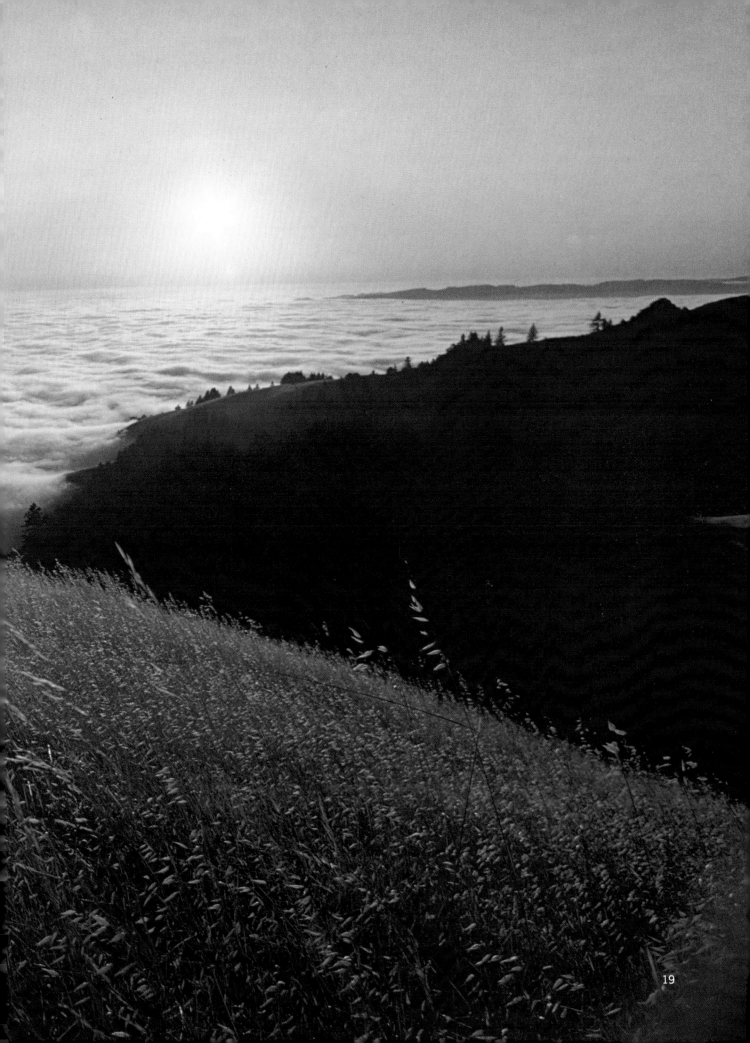

people to give him reading lists and then plowed through every book they suggested. His work began to include visions of hope for a fuller future, a more joyful life. Fusco thinks of himself as a pessimist, ready to see the grimmer realities of the world, but this new view seemed worth a try. "I don't think we can hide the reality of life," he says, "but you do have to look for ways of presenting an alternative to what we have. It might be the wrong one, but you have to push here, take a look there. Maybe something will come of it."

The journalists covering the emerging "human potential movement" began to see California as a laboratory of social and cultural change, and Fusco's assignments began to take him frequently to the West Coast. He and his family would move from Manhattan to Mill Valley, near San Francisco, in 1970. A year before, they rented a summer house in the California beach town of Bolinas while Fusco worked on *Look*'s Seventies issue.

The intellectual part of the concept was clear enough: Humankind has a better chance than ever before to make a good life for itself, thanks to its ability to learn and to a technology that might be bent into helpful channels. But Fusco and the other members of the team producing the issue spent hours searching for ways in which he could put a visual, emotional handle on the concept for 34 million readers wearied by the Vietnamese War, domestic assassinations and a sense of national uneasiness. Finally, they decided to start off by rekindling a sense of adventure. How to do that? What theme could possibly be universal enough to appeal to all segments of the mass audience?

Why not start at the most basic level, by rediscovering Earth itself? After all, the planet would still support its people generously if they just remembered to treat it with respect. But a collection of beautiful nature pictures would be a bore. The essay needed people. An approach emerged from all the talk: Fusco would construct a tale in which a pair of children find themselves set down on a planet that they see, for the first time, with clean eyes.

Now he could move. He wanted some control over his situations, but not so much that they would look stilted, so for models he turned to two children he could trust to gambol with no awe of the camera: his own.

The essay was well under way one evening when Fusco pushed his chair away from the family's dinner table. "Let's go up on the mountain," he said. "We'll see if there's any sun up there."

A blanket of chilling fog had hung over Bolinas all day, but he knew the peaks of the Coast Range often poked their heads above it. From checking the newspaper that morning, he also knew the sun was not due to set for

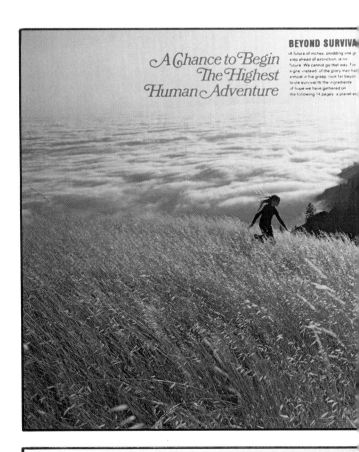

BEYOND SURVIVAL

A Chance to Begin The Highest Human Adventure

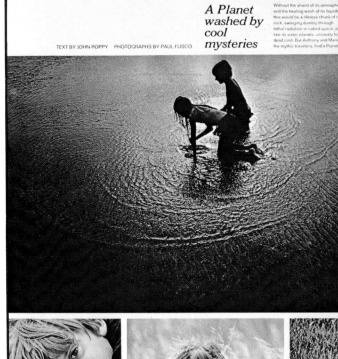

TEXT BY JOHN POPPY PHOTOGRAPHS BY PAUL FUSCO

A Planet washed by cool mysteries

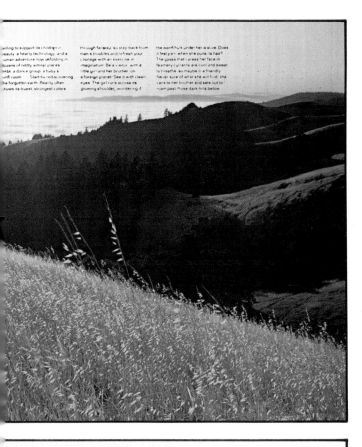

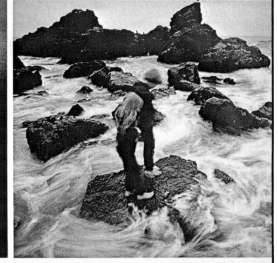

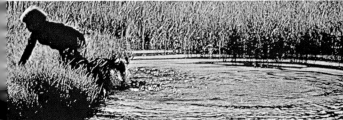

another hour. He and Marina, his nine-year-old daughter, drove up the road connecting their cottage with a flank of nearby Mount Tamalpais. As they broke into clear air, they both gasped.

The world seemed to be floating on a sea of creamy fog that was about to swallow the evening sun. Fusco had been to this spot many times and knew that some evening he would see such a thing, but he had never before seen it like this.

Incredible, he thought. Unbelievable. "How do you feel?" he asked Marina, watching as her young eyes took in a sight to which she could not respond with words.

"Do whatever you feel like," he told her. "Anything you want." Marina reacted by rolling in the high grass and then dashed off across the mountain's curved shoulder. As she played, he followed her with his Leica MP camera, shooting and waiting for the sun to drop lower in the west.

He would have only a few minutes at most to make the picture he wanted, and he might not see such a thing again before the deadline for the essay. An incident light meter gave him a quick reading of the sunshine falling where he stood. He had pulled from his bag a camera with a 21mm wide-angle lens to encompass the scene around Marina's running figure. With the camera's Leicavit rapid-wind attachment he could shoot almost as rapidly as if it had a motor.

Each time he made an exposure, he changed the aperture by half a stop to protect the picture, since he was not sure what lighting effect would most truly describe the emo-

tional content of the moment. No light meter, no matter how accurate, can interpret emotional impact. Under the strange backlighting atop the mountain, as he shot directly into a disappearing sun, he knew the meter could serve only as a basis for his own calculations. He bracketed by about three stops on each side of the meter reading, covering the full range of possibilities from dark silhouette to high-key overexposure.

Fusco did not know at the moment that he had just made the opening photograph of his essay, but he and the writer knew it a few weeks later when they saw the picture glowing up at them from his light table. They had already completed the second half of the essay, covering computers, nuclear reactors, rocket engines and other examples of technology (not shown here), so he continued his search with the children.

Marina and her brother Anthony, then 11, visited some of the most spectacular scenery in western America, from Pacific tide pools to Death Valley, the silvery ice caves of Mount Rainier and the Olympic rain forest. Fusco was bringing the children into contact with nature's brilliance, recording the meeting with his cameras.

At each stop, he trailed behind them and photographed their reactions. He never asked them for a specific pose or tried to coax them into an unnatural response. The reaction, the discovery, had to be their own. Yet Fusco was definitely the impetus for their being in such locales and his purpose was clear — to wait until the children's actions illustrated the pre-deter-

mined concept with which he was working.

Fusco's casual surface is deceptive, masking as it does the fierce attention to detail that makes him 10 times the technician anyone expects of a man with a tattered canvas bag containing several cameras so worn that the brass shines through the enamel on their bodies, a man who answers questions about technique with, "Oh, I don't think much about that kind of stuff after all this time." Pressed for details, he turns out to think quite a lot about it. When a situation is about to change and the light is difficult, technique can make the difference between communicating forcefully and missing the picture. "Getting command of the fundamentals of lighting, lenses, film and so on," Fusco says once he decides to talk about it, "frees you to concentrate on the content of a picture."

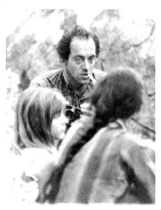

An example: The difference in light levels between inside and outside the Mount Rainier ice cave at the right was tremendous, but Fusco saved the picture he wanted by exposing for the sky outside, thus silhouetting the children — and covered himself by bracketing a little. A 21mm lens emphasized the eye-like opening of the cave, just as a 180mm

lens emphasized the bulk of the sand dune in its companion picture. "Things like inclines never look as big or steep as they really are unless you enhance the feeling with the lenses."

Fusco's equipment is very nearly an extension of his eye and hand. His basic arsenal consists of four 35mm cameras, each equipped with a lens of a different focal length: three Leicas for a 21mm, a 28mm and a 35mm, and a Nikon F for the 180mm lens. In his gadget bag he carries lenses for special situations, from a 15mm wide angle to a 400mm telephoto. On most jobs, however, he wants to record the action around him without interfering with it, so his four basic lenses stay on the same four camera bodies. Whether he is photographing his children at play on the planet, or a miner's plight in Kentucky (pages 40-47), this arrangement provides him with ready access to a camera and lens that will fit what he sees in front of him. Fusco finds the four lenses sufficient for most situations. Not only do they give him a number of ways to frame any subject, but carrying each one mounted on its own camera means he can make his choice fast; time spent removing and replacing lenses could mean missed pictures, and the commotion of all the changing around could distract a subject at close quarters.

To an essayist who might shoot hundreds of pictures for every one that finds its way into the final exhibit, 35mm cameras are indispensable. The Leica caused a revolution in photography when it was introduced to the public in 1925; its compactness, quick handling and 36-exposure film rolls

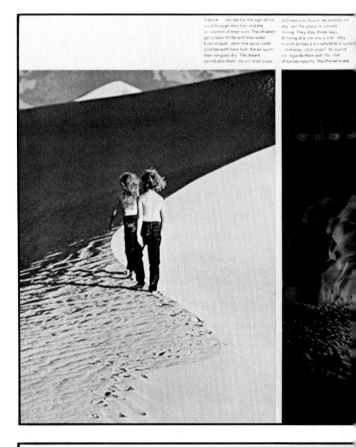

Breathing, sharing a darkening ai.

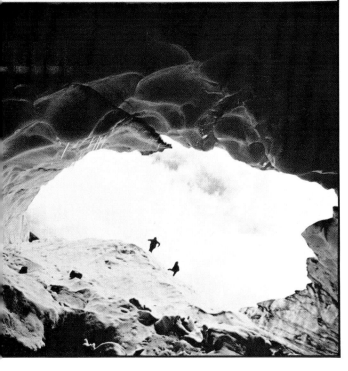

expanded the horizons of all photojournalists, whether they dealt with news pictures, portraits, sports, or essays. The quiet shutter helps Fusco avoid intruding on situations he wants to record. The rangefinder, allowing viewing and focusing through a clear window separate from the optical system of the lens, helps him work accurately in low-light situations that are sometimes difficult with through-the-lens systems.

On the other hand, the easiest way to see what you are going to get with a telephoto lens like Fusco's 180mm is to mount it on a single-lens reflex (SLR) camera like his Nikon, then frame and focus through the lens. The slightly louder noise an SLR mirror makes as it pivots out of the way for an exposure is no bother to a subject far away enough to call for a telephoto.

When he finished shooting the Seventies essay, Fusco stacked up boxes containing thousands of color transparencies and began sorting. Into the first discard pile went the missed moments and the culls from bracketing—bad exposures, an occasional shot in which the depth of field was not what he wanted. Although he shoots a lot, he concentrates on every frame, and there were surprisingly few mechanical rejects.

Next went the good exposures that, for one reason or another, did not fit the mood he wanted in the finished essay. Finally, narrowed down to a few hundred images, the take was ready to show to the writer and art director.

Fusco's tendency to "bracket, bracket the hell out of it" applies only to color essays, since his control over highlights, shadows and tones in a color picture is limited pretty much to the moment of exposure. If one portion of an otherwise good picture is underexposed, he cannot save it in a darkroom as he can a black-and-white print. That darkroom control made black and white the *vin ordinaire* of all early essays; Fusco and others still favor it for social documentation, where color would often be falsely gaudy, and for situations in which they must shoot when something happens, whether the light is good or not,

As he sorted, he did what he still does today, following the rigorous habits of his school days. He studied minute details in each picture as it went by.

His practice has not changed. Recently, Fusco sat hunched over the small light table in his converted garage. Unlike McBride and many other photographers who publish as widely as he does, Fusco has no studio, just a workroom. Photojournalists seldom maintain studios, since they spend the bulk of their time photographing the world outside, instead of a created environment inside. Behind him stood a row of file cabinets containing part of a life's work of slides and prints; the rest of his files are at Magnum, his agency, and the Library of Congress. He pressed his eye against the cup of a magnifying glass, peering at the details of each transparency in front of him. He pushed one away across the white surface, only to pull it back suddenly and search the image once more. This is a process of criticism, one whose reward might come the next time he picks up a camera.

23

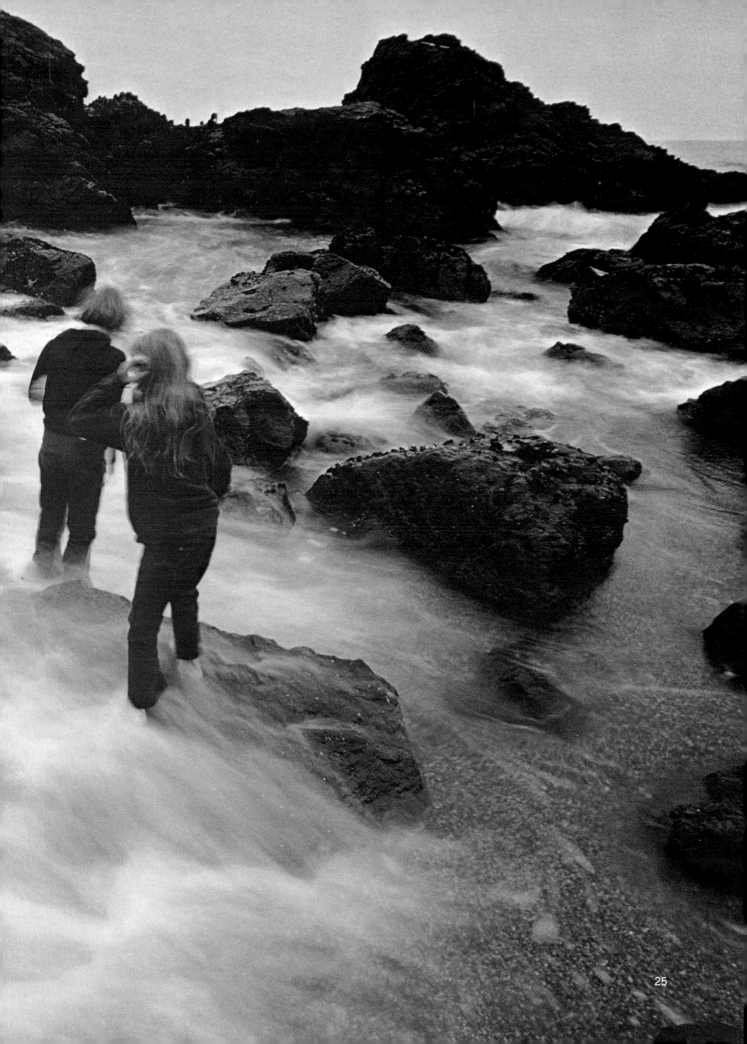

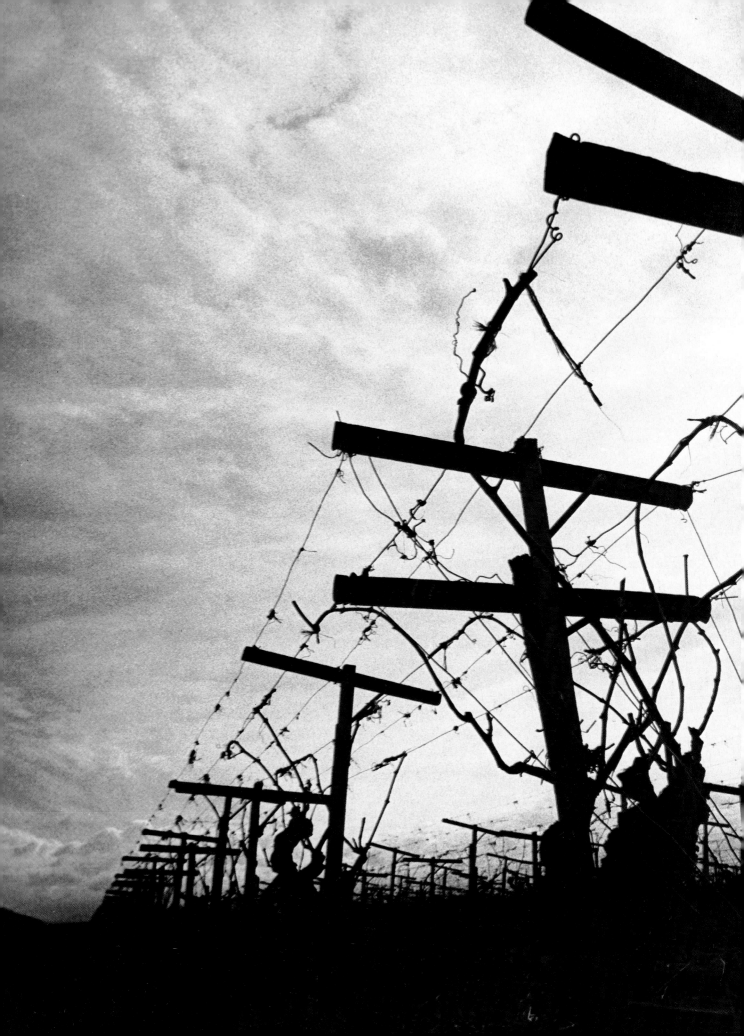

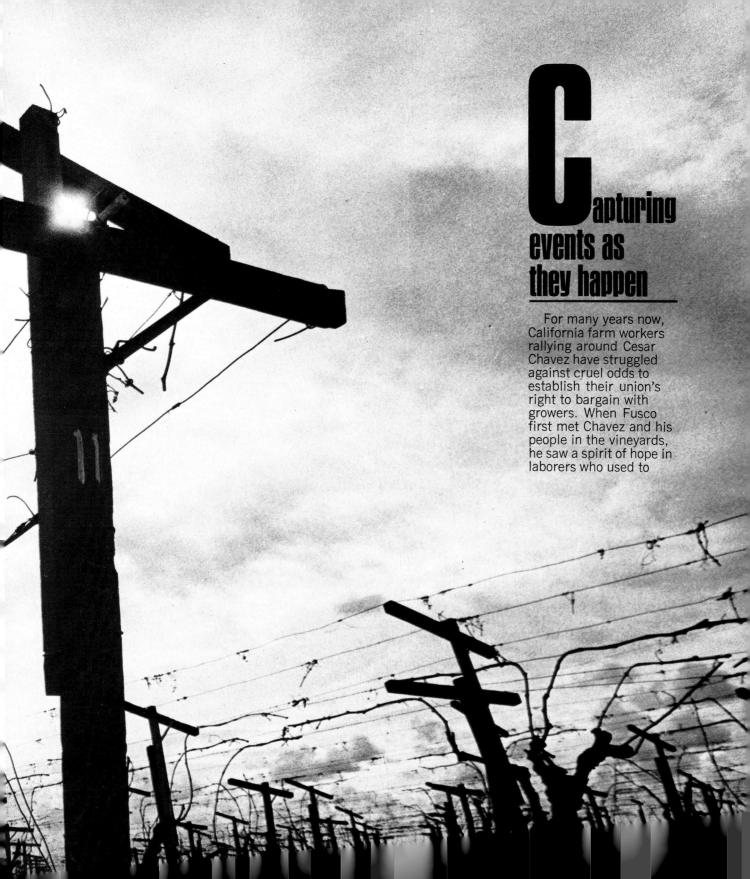

Capturing events as they happen

For many years now, California farm workers rallying around Cesar Chavez have struggled against cruel odds to establish their union's right to bargain with growers. When Fusco first met Chavez and his people in the vineyards, he saw a spirit of hope in laborers who used to

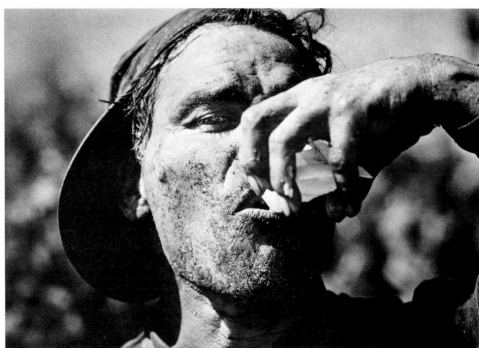

have none, and he began six years of work on a series of pictures that would alert the public to the lives from which that hope sprang.

Fusco was looking at a news event that is still in progress. Picket lines and arrests marking the United Farm Workers' battle have often drawn camera crews and reporters from around the world into the San Joaquin Valley. As a result, he recorded both fast-moving situations and symbolic ones such as a 21mm view of grape arbors stretched against a winter sky. His record of what he saw in the con-

text of the news events was published as a book, *La Causa,* from which these pictures are taken. As they appear here, they are not that essay. They are an example of the way in which a group of dramatic photographs can be laid out to illustrate some facets of the farm workers' lives without relating to each other in the fully rounded, resonant ways that make an essay.

Fusco seldom had to slip unobtrusively into the scene around him. Story-hungry reporters maneuvering for position sometimes overshadowed the farm workers them-

selves, so his main concern was that he might miss a situation or a sub-event that could later turn out to be an important link in the overall essay. Aiming for lasting effect, for an interpretation of events that would do more than summarize what an audience already knew, he worked from a viewpoint that would not die with the events themselves—he looked for situations with strong symbolic content, particular groupings that spoke more clearly than some of the action taking place nearby.

Even trudging through the fields, he hauled his

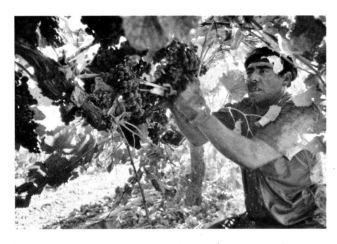

bag and his four standard cameras along. The 28mm lens caught the look of a mother living in a cardboard house, the 180mm zeroed in on a rare moment of rest for a grape-picker who works in the sun at a frenzied pace for a whole day almost without stopping—"The hardest work I've ever seen anyone do in my whole life"—and the 21mm caught a moment of the work itself (above).

His picture of Chavez parading, on pages 30-31, was shot for color space in *Look* and converted to black and white for *La Causa*. To stay as free as possible of mechanical distractions in a fast-moving situation, Fusco prefers not to mix color shooting with black and white; "You think differently, you see things in a different way with each." If it is absolutely necessary to shoot both on the

same day, some photographers try to use films with almost identical ASA ratings—Kodachrome 64 and Plus-X Professional, for example.

They can also simplify the problem of exposure settings by keeping either shutter speed or aperture constant, and adjusting only the other.

Fusco likes wide-angle lenses for the sense of context they provide, but is quite ready to use a telephoto to stand away and observe, to remove subjects from context, to compress distances whenever such effects

might strengthen the statement he wants to make. For one such photograph, he pulled himself from a motel bed one morning long before sunup and drove through a thick ground fog toward a vineyard where farm worker pickets were maintaining a round-the-clock vigil for their cause. Stationed beside them was an old automobile that Chavez used for transportation years before, at the birth of the movement. The car, no longer in running condition, had been converted into a shrine to the Virgin of Guadalupe.

Fusco wanted all those things in his picture. He knew the morning fog would present formidable problems, destroying most of the contrast in the negative, but he not only planned to compensate in the darkroom; he also planned to emphasize the flatness of the scene with a 180mm lens. He backstepped across the cold earth, squinting through the pentaprism of the Nikon. The long lens, making the fog appear to crawl into the foreground and drape over the men and their small outpost, created the effect Fusco wanted— a silent vigil, a symbol of the farm workers' quiet endurance, that helped him tie together what he wanted the world to know about them.

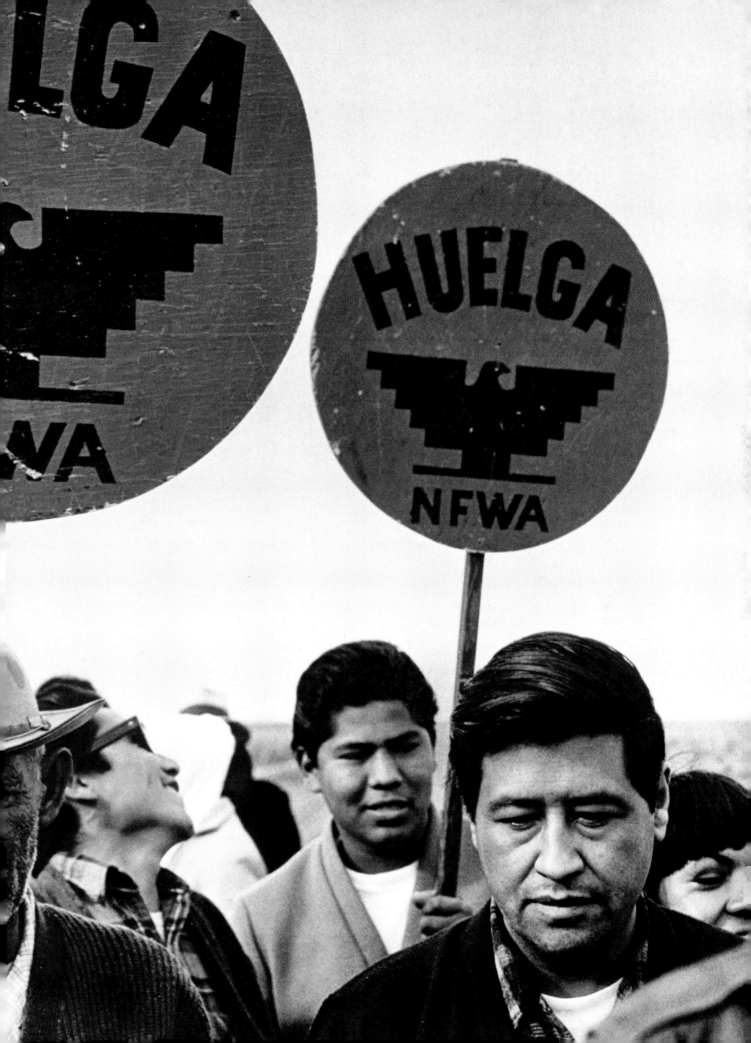

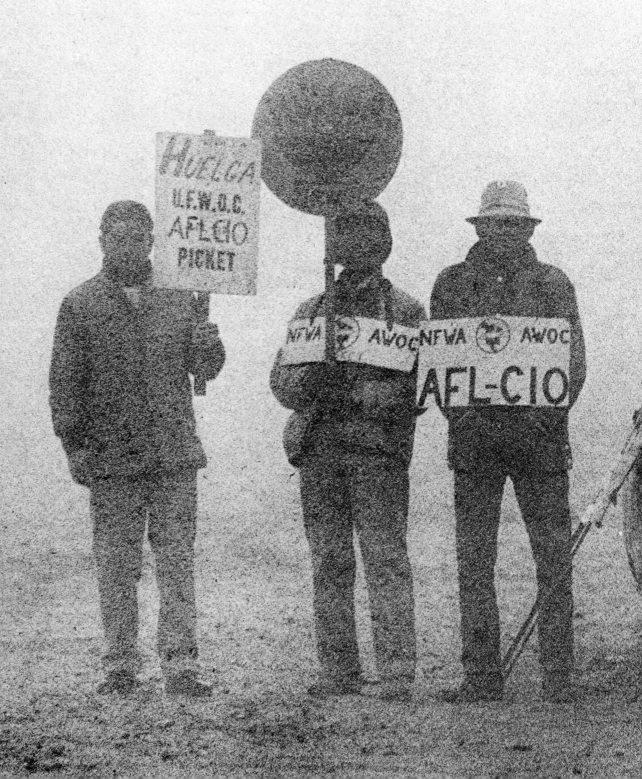

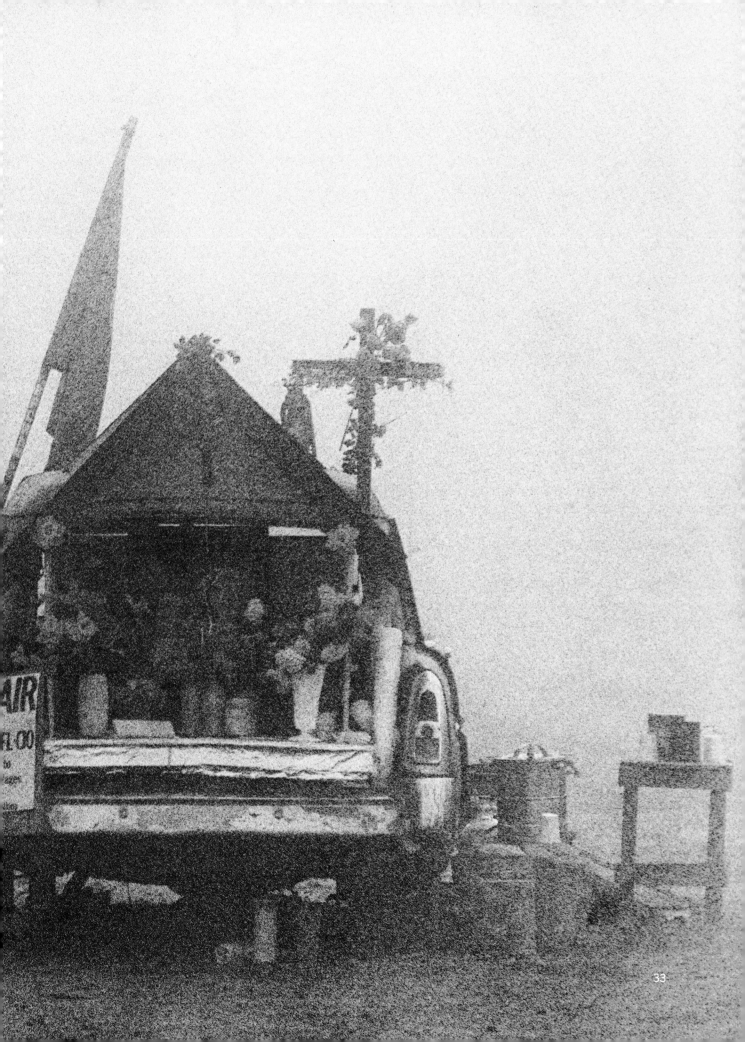

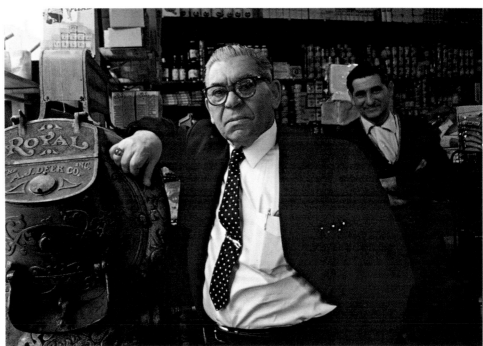

Portraying segments of society

A man framed in the window of his East 121st Street apartment yells down at the group on the sidewalk below. "Hey, whitey! What you doing down there?"

An answer comes from a neighbor leaning from an adjacent window. "They're lost," she laughs, "that's all."

The four men on the Harlem street pay little attention to the banter above them. Writer Ira Mothner continues talking with the two young men in front of him, asking questions that are slowly beginning to bore them. Mothner's wife had once been their teacher, but the 16-year-old friends dropped out of school to take jobs in the garment district. They talk of returning someday to classes, but their voices lack conviction.

As the questions and answers rebound, Fusco circles the trio with his cameras, using the conversation to erase the subjects' tense apprehension of being photographed. When necessary he draws attention to his work, asking them to move a little closer or turn their faces a bit for

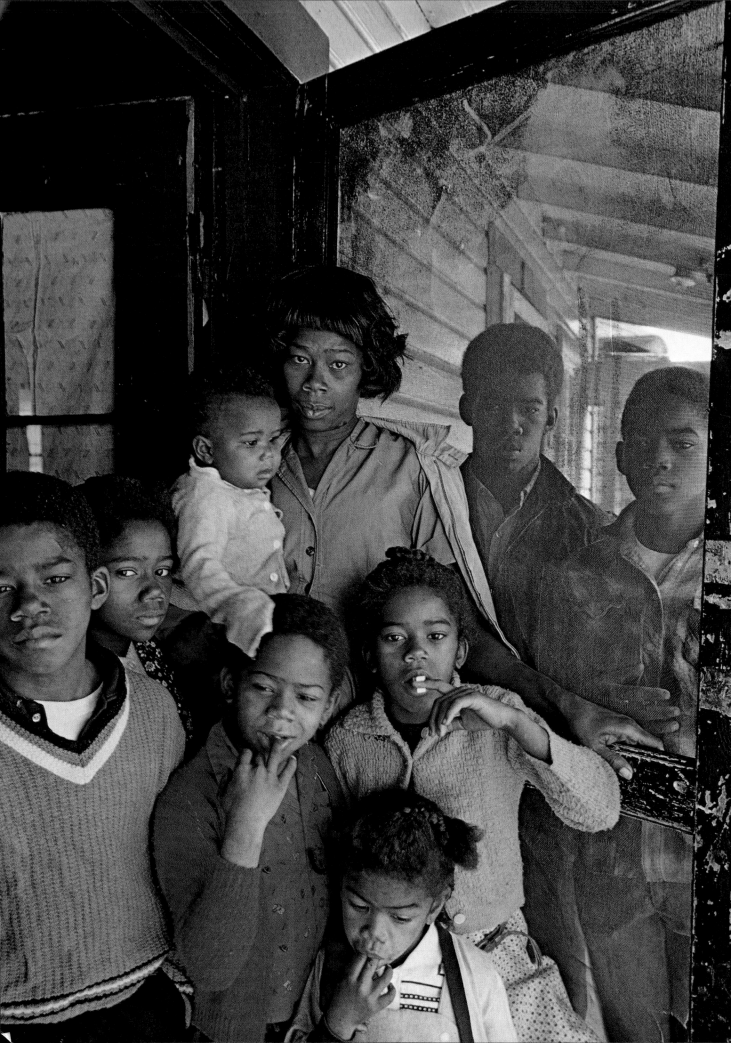

his camera's sake. There is no direct sunlight, only a cool, shaded light slipping between the buildings. Fusco knows the Kodachrome II film in his camera will build up blue tones in the shadow areas under these conditions (a tendency that Kodachrome 25, Kodak's recent replacement for Kodachrome II, does not have). He could correct the film's reaction by using a color-compensating filter, but the blue is an effect he wants; he feels it as a color of the streets of Harlem. It fits in well with the emotional tone he is seeking.

Suddenly a streak of sunlight falls across the dark walls. Fusco asks the young men to move until it brightens the face of the one in the foreground. Another shout comes from the windows above, but the photographer's concentration leaves him deaf to it.

The faces on these pages are separated by thousands of miles, by racial complexion, by economic and social position. They are portraits of American city dwellers, used originally to illustrate Mothner's argument that most of the tensions of urban life come from sheer numbers, as people rub their obvious differences against each other.

No traditional story line connects these images, yet together they mirror an urban dilemma and offer the viewer a look at the contrasts that contribute to the dilemma. Some traditionalists might call this

collection of pictures a portfolio. For Fusco, however, the overlying theme and the care with which he balanced one picture against another define it as an essay, presented here almost as it appeared in *Look,* albeit one constructed as a series of portraits.

Because it shows so clearly the influence of the photographer, it is a departure from the less manipulative "fly-on-the-wall" style that Fusco prefers. Obviously, someone asked Anthony Polcari to take time out from his customers, asked alcoholic Lester Rodgers to show off his neighborhood, Minnie Parker and her children to gather by the screen

door of their home, Burt Sugarman to turn his attention from the dashboard dials of his automobile—but only after painstaking observation of the real world of the city. There are no actors or models here. Fusco canvassed friends and prowled neighborhoods before settling on each subject, then spent time

talking with each of them, watching, to get an impression of the surroundings that would represent them most fairly. Only then did he pose them for environmental portraits.

Symbols count heavily in such situations. The battered screen door on page 36 not only comments on the family's share of the American dream, but also acts as a dimensional enhancer, adding an extra plane to the picture. The steel body of a luxury automobile fills almost the whole frame at the right, allowing the eye to find, almost as an afterthought, the couple caged within it.

All but the photograph of the family on page 37 were made with wide-angle lenses. Aside from its ability to gather in as much context as the photographer wants, the wide-angle's great depth of field makes backgrounds seem quite separate from subjects in the foreground while keeping both in focus; it therefore gives a scene a strong feeling of depth.

Fusco decided to avoid artificial lighting in these portraits. He could have sharpened some details by using lights—many photographers carry electronic flash units to do just that—but felt they would have falsified what he saw as reality. Once he had made that decision, the choice of Kodachrome II film followed naturally; he needed all the acuteness, contrast, and color saturation he could get, and knew the fine resolution of the film would allow a transparency only 1½ inches wide to be enlarged to the size of a big magazine spread with only a small sacrifice of quality.

Sharing human problems

Beyond the information they convey—does a coal miner's cabin have plumbing? What does the machine that took his job look like?—Fusco's best essays enfold a viewer in the emotional bond that develops between photographer and subject.

The jobs of families who had worked the coal veins of Appalachia for generations were being destroyed when Fusco arrived to report on the human costs of strip mining. Reproduced on these pages is a nine-page social document that journalism departments in a number of universities regard as a modern classic: an essay that presents the large theme of brutality in the name of profit, and flows from beginning to end as a story of one family's suffering.

Fusco made more than a thousand exposures. From them he selected

40

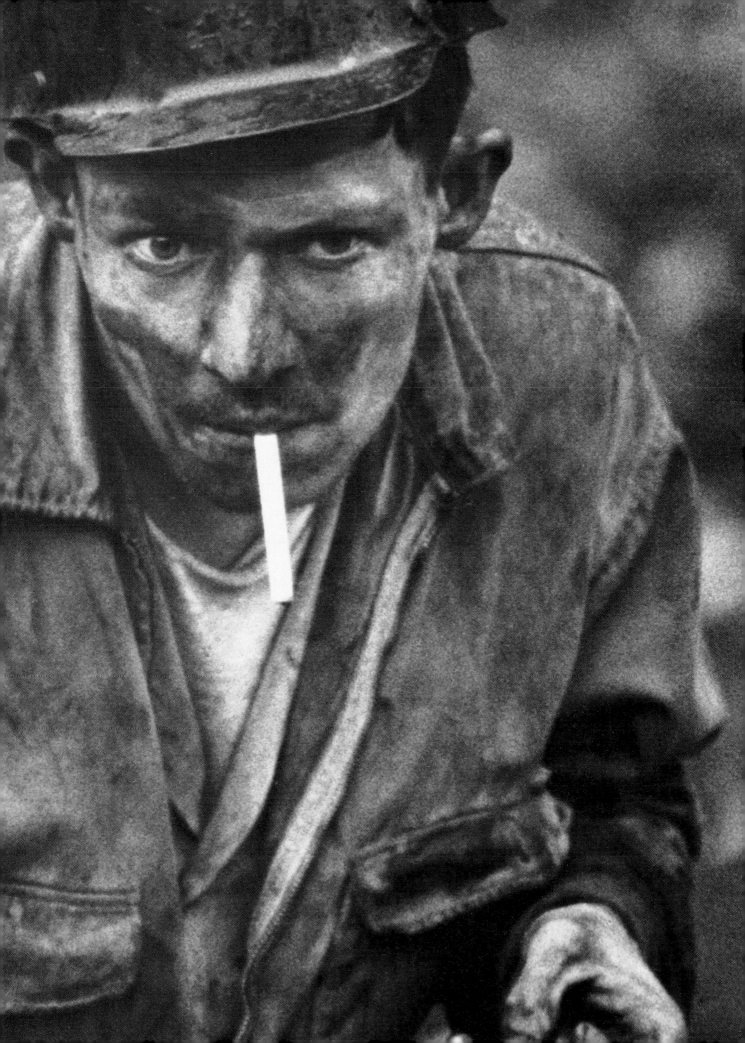

10 that interact with each other to suggest, in as tactile a way as he could arrange, what it was like to be in George's Branch, Ky., in the winter of a bad year. To do the essay, he spent six weeks focusing his attention on the family of a crippled ex-miner named Rado Combs.

Fusco's low profile encouraged the family to accept him and his cameras as part of their lives. He started taking pictures the minute he arrived in their house, to establish himself immediately as a photographer instead of someone trying to smile his way into their confidence to snatch some photos later. Writer William Hedgpeth came and went, but Fusco stayed with the family, recording daily activity, finding an impressive endurance in the way they worked, day after day, despite their worry about Combs' illness and their financial plight.

To put the viewer in touch with the environment of that plight and one cause of it, he cut away occasionally to find a picture like that of the auger at the left. "The mining companies really destroy the ground with that thing," he felt, so he got in close and used a 21mm lens to interpret the tool as an ominous threat. Once the psychological point was made, he surrounded the picture in the final layout with images of the people affected by it.

To make the closing portrait of Combs (page

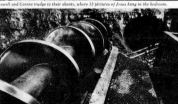

Lowell and Corene trudge to their shanty, where 13 pictures of Jesus hang in the bedroom.

Lowell, 30, spends his days stooped in blackness thousands of feet under a mountain, loading tons of coal to take out. When he comes into daylight, his eyes are wide and deranged-looking, like an angry owl's.

obstacles to this hope—for Rado or for the rest of the mountain region—are as high as the vast mountains themselves. There is today a growing demand for coal to make electricity, but practically no demand for local people to mine the coal in the old way. Instead, a half-handful of men with strip machinery can literally chop the top off mountains, scoop up the exposed layer of coal and heave the debris over the side to form huge sliding aprons of sulphur-poisoned mud with bits of blasted stump and stone that clog streams and sweep away the homes below. When the machines move on, the earth, for miles around, looks as if it had caught smallpox and died.

RADO COMBS is not yet dispossessed. Unlike most, he owns the mineral rights to his little mountainside farm. For asserting these rights, he ran afoul of some economic interests. One day last May, two "polices" jumped Rado in his garden while two other men rifled his house and beat up his 18-year-old daughter. The effect of this and a night in a wet, unheated jail cell stunned and destroyed his mind, and left him like a soldier in a permanent state of shell shock.

Doctors all say, yes, Rado *is* totally disabled, but somehow this isn't enough to coax the courthouse gang into approving any welfare or even Social Security disability pay. So, he sits dazed and immobile in his shanty before a constant coal fire, attended by his wife Mary and the seven of his children who live with him, plus Lorene, who lives higher on the mountain, and Corene and Corene's husband Lowell, who, like Rado, became a miner at 16.

Lowell works in a deep mine in George's Branch where he runs a battery motor, a low-slung car for hauling coal out of the hole to the waiting trucks. Each day after work, he drags himself to Rado's house, totally defeated-looking and filthy except for eyes peering white, blue and bloodshot from under a coal-smudged face and

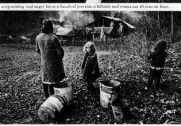

A strip-mining coal auger bores a hundred feet into a hillside and reams out 45 tons an hour.

Three of the Combs children go out in search of loose coal to keep the fires burning at home.

Irene is young and lively and attractive to young men. She jokes a lot and laughs a lot and works a lot, and her hands are becoming hard and her shoulders are sloping and her back is growing bent with heavy lifting.

black miner's helmet. He takes his place before the fire in Rado's bedroom along with perhaps one or two other visitors who pass time here in the spirit of a slightly premature wake.

RADO sits in a straight-back chair, kink-necked and gazing into the coals with eyes that don't quite focus on anything. His head and hands shake and his raft-like legs sprawl aimlessly in front of him. His friends may talk to him not as he endlessly recounts that incident months back when the "polices" came down on him and put his poor mind all shook up.

The coal glows: "They's no greater life on earth than farmin'," Rado says, his head still oscillating from side to side, eyes blinking, still looking into the fire, "'specially in the summer season. Watch things grow. Hit's like coal mining. That's somethin' must be looked after. And the laborin' class is people. That's somethin' else must be looked after. But these politicians and strip folks figger it the opposite way.

I jest don't know what's wrong with this country, do you, Lowell?"

"Well . . . " drones Lowell, sitting back in his chair, "one thing wrong is they quit farmin'."

Sherman, Rado's squinchy-faced father, who is somewhere in his seventies (he doesn't know just where), is chewing tobacco with ut his teeth so that on each downward mouch, his chin rubs his nose. He bums against the mantle, one hand hooked to his overall strap, and spits—hiss—into the coals. On the mantle are patent medicines for Rado, a framed photo of the Cartwright family in Bonanza and a small snapshot of a man lying dead in his coffin. The rest of the room is ragtag but neat, Mary does so much housecleaning as she is able, what with ministering constantly and lovingly to her husband. Usually, though, the beds are made, meals are cooked and washing done by their 25-year-old daughter Irene, who—in spite of two babies of her own—has managed successfully to avoid marriage, but not the beginnings of the stoop-shouldered stance common to mountain working women.

Uncle Ed, Sherman's brother, enters the room where the men are and sits quiet as a ghost on a trunk in the corner. He lives here and pays for his keep with $20—half of a monthly pension check from somewhere—which is Rado and Mary's only source of funds. They must then scrape together two more dollars to add to this amount in order to purchase their monthly food stamps—which, in turn, buys them enough groceries to last only about two-and-a-half weeks. Rado, who has been talking aimlessly on about something, stops, gropes for a fact, misses and chuckles sadly, "My mind hain't a inch long." He pauses again and, looking at no one, declares, "A man who's used to work get whar he cain't work'll never be satisfied again. I don't like to get
continued

The smaller children waste away in the house: no dolls, toys, TV, no music.

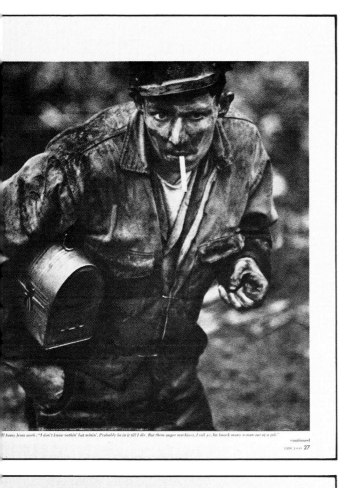

At home from work: "I don't know nothin' but minin'. Probably be in it till I die. But them auger machines, I tell ye, hit knock many a man out of a job.

continued

LOOK 3-4-69 **27**

Combs loves "sp'ih' holler" with her sister, but spends all her days tending to her damaged father, and to the wash, and to the kids and to the mine.

LOOK 3-4-69 **29**

45) and the portrait of Combs' son-in-law (left, and pages 40-41), Fusco used a 180mm lens not for any special effect but because he had to. He was separated from both men by obstacles that made it impossible for him to move closer and a shorter lens would have left the figure of the man tiny, lost in too broad a sweep of context. Although Fusco has the steady hand that a candid telephoto shot requires, he is not satisfied with the picture of Combs at the end of the essay: "It isn't as critical as it should be for such a big blowup. But that's just one of those problems. When you're not able to maneuver into the position you'd like to be in, you do have all sorts of things to help you out and correct the distance."

What do you talk about when you're watching someone do the wash for six weeks? "Who knows? Most of my talk with the people I'm photographing is kind of peripheral. For closeness, for a natural relationship, sure, I get into conversations, but I don't talk all the time I'm taking pictures. When I'm trying to work, I don't remember what I said or what they said."

What he does do is "concentrate on what I'm looking at, so I can understand what the hell I'm taking a picture of." He makes hundreds of quick decisions every day—how much context a picture needs, what belongs in and what doesn't—and moves left, right, up, down, to place the elements of each picture in the relationship he wants.

Staying with the people until he knew them helped Fusco anticipate situations he later used as symbolic elements to tie the essay together, to make strong statements within the context of his theme.

43

When an old miner picked up a pail one cold night to fetch some coal, Fusco followed him to talk and to see where he would go. They came to the mouth of an abandoned mine shaft. "I saw that hole in the ground," Fusco remembers, "and I knew—aha!—here comes a picture. The opening was so low that he couldn't just walk in, fill the pail and walk out. He was going to have to stoop over, then turn and struggle to get out." To emphasize the stoop, Fusco noticed a mantle of rock that would seem to press down on the old man's shoulders when he turned, "and to me it meant a whole sense of weight, the burden of the man's life." The extreme wide angle of a 21mm lens might have made the figure too small among the rocks unless Fusco moved closer and risked a distortion of perspective—the edges of the picture falling away, deemphasizing the weight of the rock—that he did not want. A telephoto might isolate the miner, making his figure so large that the context would be lost. Fusco decided his 28mm lens would give him the sculptural quality he wanted, putting the miner and the rock ledge in just the relationship that would make his point. Positioning himself to show the weight of the ledge close above the man, he pre-focused on a stone at the opening and waited for the weary miner to turn.

Throughout his stay in George's Branch, Fusco adhered to his normal practice and worked with the light he was given in each situation. Indoors, that meant very low light levels. "Their windows are small, and they use tiny light bulbs because they can't spend a lot of money on electricity... It kind of gave me the

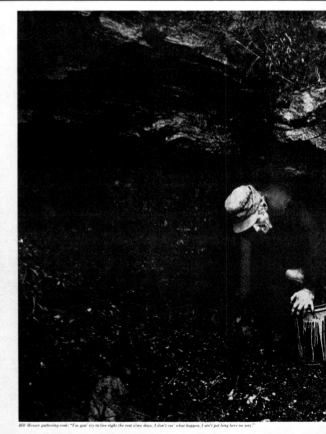

Bill Messer gathering coal: "I'm gon' try to live right the rest o'my days, I don't car' what happen, I ain't got long here no way."

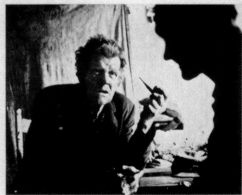

Rado, at home, before the fire, darkness falling, people like Bill Messer there, as always, to sympathize and listen.

Ex-miner Bill Messer is Kentucky Gothic, with ropy hands and merry eyes and skin so imbedded with coal dust that it'll never wash clean. On his wall hangs a varnished wood plaque: "Jesus Never Fails."

whur people have to help me. I jest ain't used to this. This ain't the life I love—bein' indoors."

OFF BEYOND the hollow, rising and fading, the wind carries the tat-tat-tat of pneumatic hammers and a fluttering, far-off rumble as a big dozer prowls the edge of distance. Just down from the Combs' house comes the whack of a hand hammer where Rado's father-in-law, Bill Messer, nails together a fresh new shanty from old boards he has collected. Bill worked all his life in the mines till his heart started acting up ("Hit don't beat normal. Hit squeak. All the time") and now hopes to live out his days in a snug shack with his pipe-smoking wife and 12-year-old grandson, Gary.

Bill pounds on a doorjamb while little Gary sits on a pile of wood with his shotgun and talks (between pauses to spit out the door) about rabbit hunting. "I want you to get that chaw of tobacco outta your mouth and quit that," Bill huffs, and then goes on with his hammering. "Aggg. I wouldn't chew that ole nasty stuff." The boy just giggles and chews on. "I reckon," Gary proclaims after a thoughtful pause (and a spit), "when I get big, I'll go work in the mine. Have to make me a damn livin'!"

At this, Bill shakes his head. "Noooo" (pronouncing it like "do"). "You 'member yore Uncle Clyde. Went all through that bad war in Germany and never got a scratch, then come back home and get blowed up in a mine. Hit laid his eyeballs right out on his cheeks."

Bill gets a small pension that goes, in part, for multicolored heart pills he keeps in a cigar box with his nails and pipe tobacco. After hammering some more, he stops, beams a bright, toothless grin and heads to the cigar box for a pill and a smoke before going up the hollow to call on Rado.

George's Branch begins with a squat brown building that serves as offices for four different coal companies. On past that are the irregular rows of ram-

continued

Rado: "Jim here, he knows how I worked." Jim: "I shore do, buddy, shore do." Rado: "I never ask nobody for nothin' after I wuz fourteen year old, I jest ain't got no strength no more."

shackle houses scattered for about a mile and a half up the hollow along a mud road. The road runs alongside a polluted creek, lined—as almost all the creeks, banks and back roads of Eastern Kentucky are lined—with the ransacked carcasses of old, rusted cars. Like the other houses in George's Branch, Rado's place—propped against a mountain near the end of the hollow—has no plumbing or running water, just an outhouse and a well. Light bulbs are its only concession to the 20th century.

ALONG WITH many other of the uneducated miners laid off when strip mining hit this area, Rado took part in the "Work Experience and Training Program" (the "Happy Pappy" program they called it here) and worked at minor construction and public-maintenance chores until the whole thing ran into a fiscal cutback by congressmen who had grown weary of Appalachian poverty.

Other Federal measures passed to aid the isolated mountain folk have at least helped stave off mass starvation, if not severe malnutrition. But the local politics, who, more often than not, work hand-in-pocket with the coal companies, do as little as they possibly can to stem the out-migration or ease the plight of the dispossessed. For all practical purposes, strippers are free to blast and gouge as they please.

This is a countryside fertile with coal and gas and other rich resources vital to civilization. The only product of the land that is nonmarketable and hence unneeded—and hence in the way—are those who live on it. Most grass-roots efforts to organize the poor or even to provide medical help run into an idiotic barrage of Red-baiting charges. The Appalachian Volunteers, for example, a U.S.-funded group of young people who oppose the effects of strip mining, have just been accused of hatching a Red plot "to overtake [sic] the mountains of Kentucky" and "subvert the government."

Buck Maggard, a 28-year-old AV,

"Never was a lazy bone in Rado Combs' hide," says Rado, reflecting, recalling, "He's been a tough ole egg in his life."

feeling that they were living in the coal mines." He worked with Tri-X film indoors and the slower, finer-grained Plus-X outdoors for two reasons. Black-and-white film conveyed the gritty mood of the place, and its latitude gave him a chance to work in difficult light knowing he could perfect his prints later in the darkroom.

Minutes after Fusco made the picture on pages 40-41, the young miner and his wife began walking toward their cabin. The soft light of a foggy day had been perfect for the close-up, but it meant trouble for the picture he wanted to use as counterpoint (page 42, reproduced larger on pages 46-47). "The dirt road and the grass and leaves and twigs around it were almost the same tone, so I knew when I was taking it that I'd have to burn in everything but the road in printing, darken the surroundings to make the figures stand out against the curve. The curve made it look like an endless trek that could go on, as far as they knew, forever. That's how it affected me, and I wanted it to have the same effect on anyone who was going to see the picture."

He spent as much as a day apiece in the darkroom with some of the individual pictures in the essay. "It is very important, when you start printing, to look at the picture as a three-dimensional object. Oh, I know it's two-dimensional, but

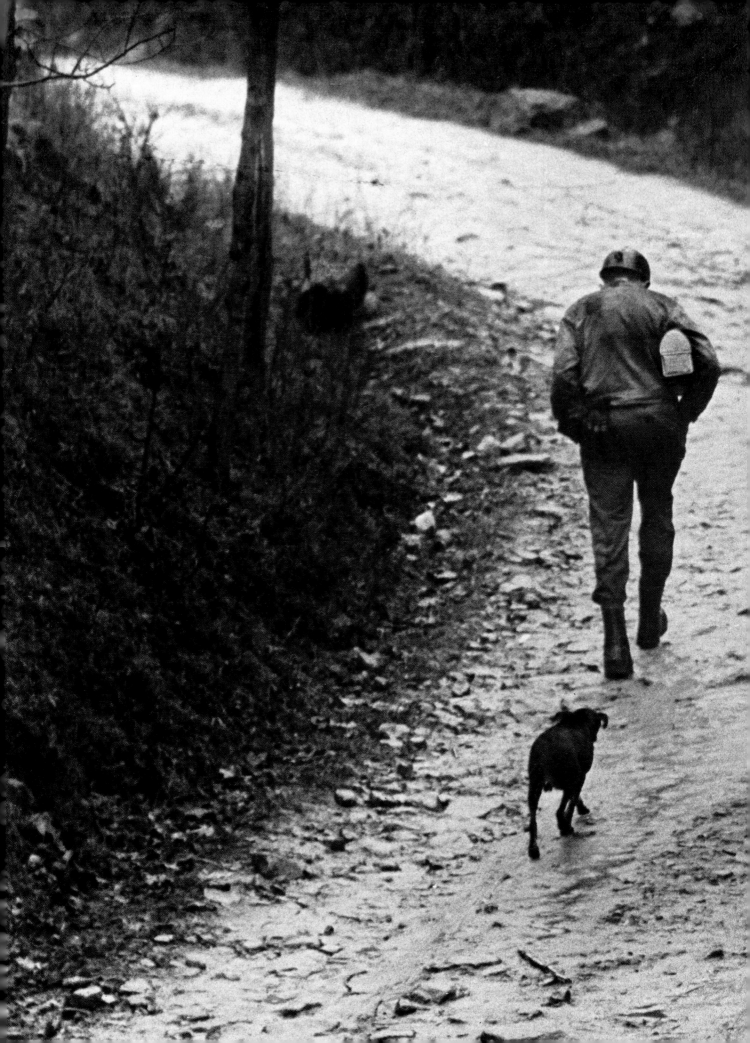

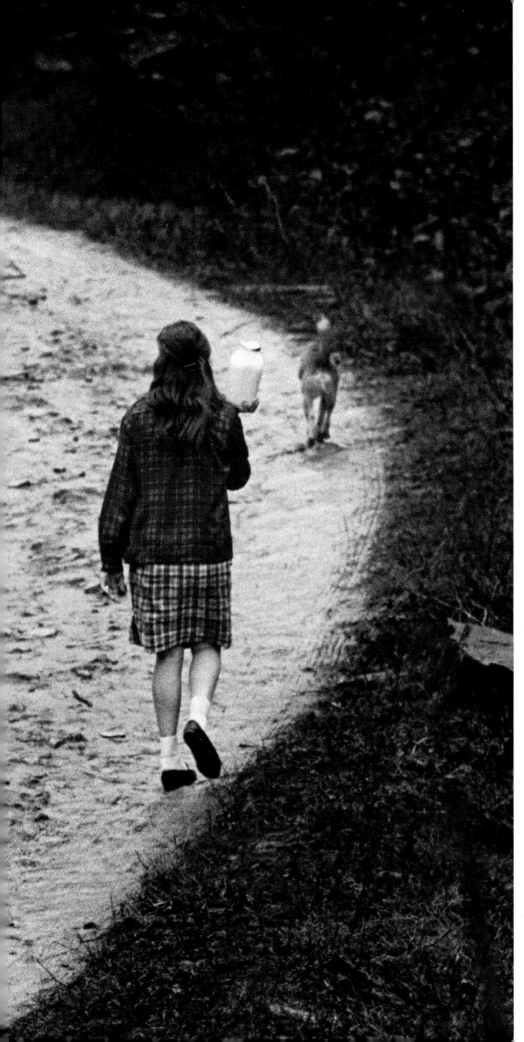

this is a matter of *feeling.*" Fusco talks about balancing a picture for the effect he wants: "It's very basic. Light things tend to come forward, dark things recede, so I try to control the print so the eye zeroes in on the things I deem most important." He prefers to print the dark areas of a picture first, then bring out the lighter areas by burning in, but sometimes finds the opposite—dodging—to be necessary. On occasion, he has cut tiny holes in cardboard and printed for an area a quarter of an inch square, burning in one detail. "You have to do that. Film doesn't understand what the picture is all about. Its total range is so truncated, compared to human vision that compensates all the time..."

Technique, however, is merely a servant. Fusco works with his cameras to understand these lives, share their problems, and share what he has learned with the broadest possible audience.

An essay, for him, is no brief encounter. "It's as if these people and situations will always be part of my life," he muses. "They are as close and as meaningful and as important as my own family, as intimate as my personal self, my fantasies, everything about me. They are just there. They live. They are right in there, alive and doing well."

Several months after Fusco moved to California, he got a letter that had been forwarded from New York. "Dear Mr. Editor," it read, "I wondered if you could tell me where my friend Paul Fusco is because I have been thinking about him." It was signed Rado Combs.

Will McBride: The essayist as illustrator

While Paul Fusco constructs essays from images he finds in the world around him, Will McBride finds his own world in the images he constructs.

McBride's love affair with Europe, begun during a bicycle tour after his discharge from the Army in the summer of 1955, coincided with a rekindling of his interest in oil paints and clay. Settling in Berlin, he sold the old Speed Graphic he had used during his studies with Norman Rockwell, enrolled in the Free University to study German, and soon began exhibiting paintings and sculpture in local galleries. He also found a quiet, dark-haired German girl named Barbara who would eventually become his wife. There was no more room in his life, it seemed, for photography.

Unharnessed from the expectations of his homeland, feeling free on foreign soil, he wanted to express what he felt about the electricity of "The Brave City" and the young Europeans who were looking for new ways to live amid the artifacts of the old. But his ideas did not translate comfortably into oil and clay. One afternoon, picking up a copy of David Douglas Duncan's *The Private World of Pablo Picasso,* he was struck by the informative power and mass appeal of Duncan's photographs. A pilgrimage to the Côte d'Azure, where he found and questioned Duncan, convinced him that photography might be his medium after all.

Two years of selling pictures for $2.60 apiece to a Berlin newspaper and occasionally to *Paris-Match* convinced him that the market had to be better elsewhere, so he and Barbara packed up their young son and moved to Munich. In 1959 he came across a startling sight—a copy of a new German magazine, *Twen,* dedicated to explorations of youthful lifestyles and designed with an eye to striking color features—and sought out *Twen's* art director, Willy Fleckhaus.

The meeting started a symbiotic alliance between McBride, Fleckhaus and *Twen* that would last more than a decade. Fleckhaus arranged steady work for McBride as a photojournalist at *Twen's* parent, *Quick,* one of Germany's large illustrated magazines, and McBride began to show off an ability to pre-visualize a picture. Assigned to cover an event for *Quick*—a political parade, say—he would decide what spot offered the best background, figure where the crowd and the sun should be at a given minute, think ahead to his position and choice of lenses, and cheerfully astound an art director by leaving on his desk a drawing of what the photograph was going to look like when he brought it in.

So much for the "real" world. Between pictures of politicians and Berlin Wall escapers, he gave an increasing portion of his energy to a fantasy world at *Twen.* His photographs would appear in many magazines besides *Quick—Ladies' Home Journal, Playboy, Look, Stern, Eltern, Jasmen*—but it was to *Twen* and the critical eye of Willy Fleckhaus that McBride turned first and most often. Together, they would explore the seductive currents of contemporary Germany in photo essays that unveiled McBride's distinctive style: the rendering of fantasy into photographic symbols.

McBride focused fanatical care on these essays. He and Fleckhaus would discuss an idea—sometimes at length, sometimes in a couple of sentences—and McBride would then retire to find a way of making photographs from the romances running through his mind. He developed a pattern he still follows: A production sheet shows, for every shot, a sketch of the idea and a list including camera to be used, models, costumes, props, haircuts, type of background, overall mood, special effects, time of day if natural light is a factor "Everything should be right there at the right place at exactly the right time, so that at the moment of exposure no piece of cloth, no stone, no flower is missing," McBride insists. "The right time for a sunset or sunrise might be

Will McBride photographing his own exhibit in Munich.

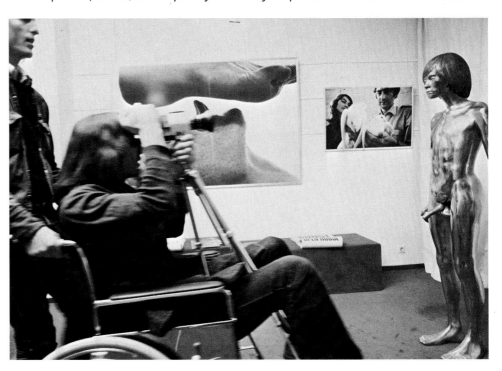

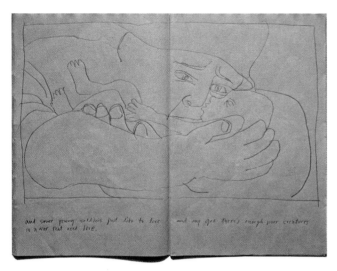

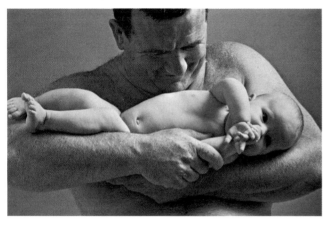

McBride's original sketch of an idea, and the completed photograph.

about one minute, after months of pre-planning."

What could possibly be worth such Prussian discipline? For McBride, one thing—promoting a way of life that makes a joke of discipline.

If photographs were to entice recruits, then they would have to stop a reader's flight through the magazine's pages. To do that, McBride put men and women of striking appearance into situations that suggested great pleasure.

His essays return often to a story line that shows a youth leaving home in search of adventure, pleasure and a life of his own, and finding all of it. This, of course, is the hero of McBride's own fantasies living out his

creator's dreams.

"Sure," McBride admits with a smile, tinkering with his new Leica. "By creating those situations, I sort of live through states that I couldn't have without the camera."

He came to regard his high-ceilinged, white-walled loft in Munich as more than a mere studio. He saw it as a social experiment and lived— to Barbara's increasing distress—in the eye of the test. Word went out to youthful vagabonds that the studio offered not only shelter but freedom. On any night it might contain 20 young men and women, sleeping bags flung in every corner, the air filled with the smell of hashish and sounds of revelry. These hangers-on contrasted sharply with the staid, prosperous Germans who populated the neigh-

borhood, but McBride hoped the two generations would meet, and that the studio would be a catalyst for social change—or at least for tolerance.

The youths ran errands for the tall, balding photographer and served as actors in his pictures. The pace increased. In a little over two years he went through 40 chief assistants. Seven days a week, often 20 hours a day, the place could erupt at any moment with McBride's triumphant shouts, or screams of fury. He increased his alcohol intake and supplemented it with Librium tranquilizers; what he recalls as a "fantastic high" lasted into the middle 1960s, but did not prevent him from producing some of his best reportage. He grew "older and older very quickly," and the high dissolved into a depression that kept him locked for long periods inside the studio, then sent him to a sanitarium for a brief rest.

Work with Fleckhaus contributed to the pressure. The art director was his friend, but their conferences would often end abruptly with some version of the same scene:

Fleckhaus: "That picture has nothing to do with what we are trying to say. Out."

McBride: "You don't understand. It was my experience. How can you

know what is important?"

Fleckhaus: "I know." He would snap off the slide projector and turn to the window of his villa. End of discussion.

McBride felt used, a mere supplier of images, but when Fleckhaus put Herman Hesse's popular novel *Siddhartha* into his hands, he was stunned by the astonishing similarity between his own experiences, real and imaginary, and those of Hesse's Brahmin. McBride made notes and sketches in the book's margins, planning ways to illustrate *Siddhartha's* message, and organized a trip to India that produced a photo essay he admires above all others. (Pages 58-65.)

Soon after his return to Munich, he got an unexpected shock. His wife left, taking their three children with her. Barbara's hopes for a stable home with a garden had finally been stretched to the breaking point by the turbulence at the studio. In agony, McBride whipped the studio into even more of a froth. Advertising executives, appalled by the frowsy, naked visitors who wandered through their shooting sessions, started withdrawing commissions; McBride shrugged. Assignments dwindled, he spent considerable time on two

Willy Fleckhaus.

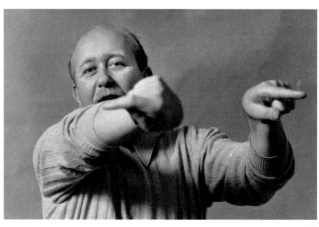

49

books on sexuality, and money ran out. Who came to the rescue with more suggestions from *Twen?* Willy Fleckhaus.

Before *Twen* went out of business in 1972, McBride produced several of his most striking enticements to the life of the senses, including "Der Neue Mensch."

The name of the **essay translates literally as "The New Man,"** but in *Twen* it meant something closer to "The New Human Being," with every good connotation McBride could put into it. "We looked around and saw how the kids were living," he says, "and tried to convince everyone to live that way."

Instead of going to the outside world as Paul Fusco would, McBride constructed in his studio a series of visions representing a new human family that had come to terms with the complexity of modern life, living in harmony with technology and nature, unafraid of stale taboos. For contrast, small photographs of

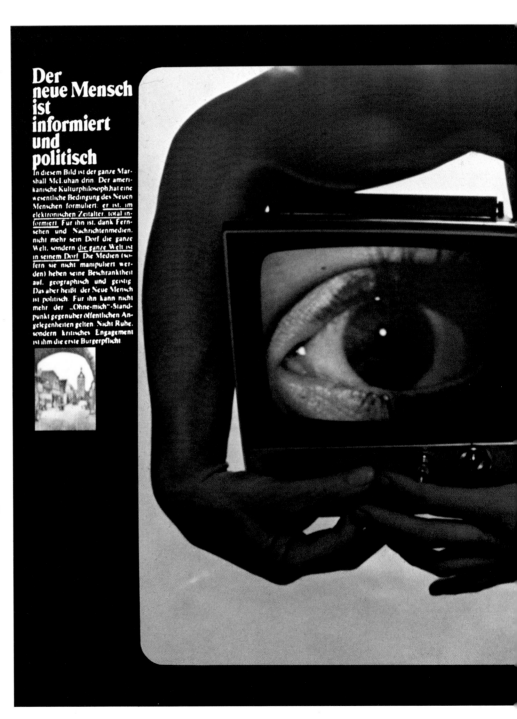

Der neue Mensch ist informiert und politisch

In diesem Bild ist der ganze Marshall McLuhan drin. Der amerikanische Kulturphilosoph hat eine wesentliche Bedingung des Neuen Menschen formuliert: er ist, im elektronischen Zeitalter, total informiert. Für ihn ist, dank Fernsehen und Nachrichtenmedien, nicht mehr sein Dorf die ganze Welt, sondern die ganze Welt ist in seinem Dorf. Die Medien (sofern sie nicht manipuliert werden) heben seine Beschränktheit auf, geographisch und geistig. Das aber heißt: der Neue Mensch ist politisch. Für ihn kann nicht mehr der „Ohne-mich"-Standpunkt gegenüber öffentlichen Angelegenheiten gelten. Nicht Ruhe, sondern kritisches Engagement ist ihm die erste Bürgerpflicht.

Germany in the Third Reich, the years of Willy Fleckhaus' youth, ran with McBride's images in the published essay. The photographs on these pages, reproduced directly from the pages of *Twen*, are part of it.

Feeling that a fear of technology had tightened up too many people's lives, McBride looked for images suggesting a way to integrate it with the body: "I mean, the whole idea of machines came from the human mind, which is part of the body, right?" He decided to photograph a man cradling a symbol of technology—a television set— that in turn embraced part of a human body.

He had never used video equipment before, so a technical adviser from Sony stood by for five hours as McBride and his crew set up the picture.

McBride tried a mouth first, focusing the video camera on the girl's full lips. Beside him, the TV screen filled with the image of a tight smile. Good, he thought, but not right. "Open your mouth," he said. "Grit your teeth. I want to see them." Two rows of white teeth fell across the screen like a necklace. McBride grimaced and shook his head in disappointment. He moved the camera in, aiming at the model's eye, closer, closer . . . "Give me some sidelight on the

eye," he commanded. As the lighting came up, his own blue eyes flashed in pleasure. The mouth, even the teeth, would have served his purpose, but the eye on the screen was perfect. He wanted that feeling of alliance between the electronic invention and the mind behind the eye.

He also wanted to make the symbol of automation

and computer control seem small, even impotent, compared to the massive arms and shoulders of his model. To broaden the shoulders, he shot with a 20mm lens that gave him the wide-angle's stretching of perspective toward the corners of the frame and the depth of field to keep all planes of the picture in focus. The rate at which the TV monitor's electron gun constructs an image by scanning horizontal lines on the screen determined the shutter speed McBride used to capture the image as it appears normally— 1/15 second for German TV. In the United States he could have gone up to 1/30 second.

He used the characteristics of certain lenses to interpret the scene for each photograph in the essay. The wide-angle— his favorite type of lens —emphasizes the bony effect of the liberated couple embracing beneath the German flag (in the days of the swastika you couldn't use a flag that way), but a 105mm telephoto gives the leaf and touching hands a planar feeling that suggests each is an extension of the other.

For the entire essay, including the apparent outdoor picture on pages 54-55, McBride bounced electronic flash off a studio wall through a spun-glass screen behind the models. He wanted the drama of backlighting along with the soft, organic feeling of daylight that strobe can provide.

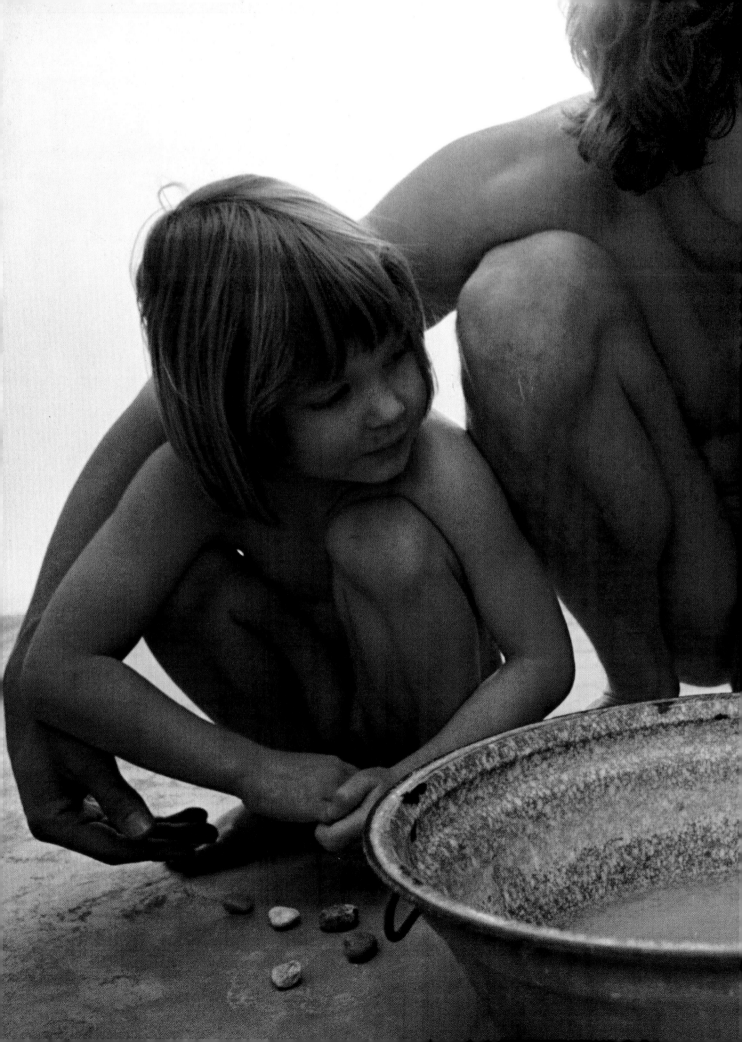

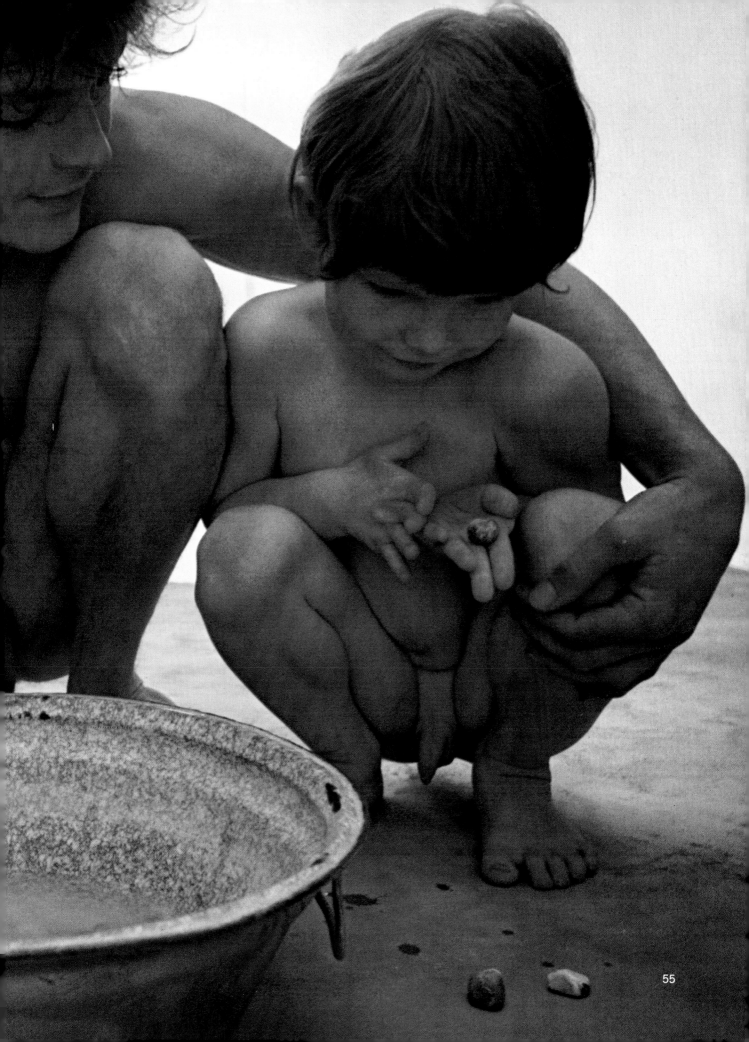

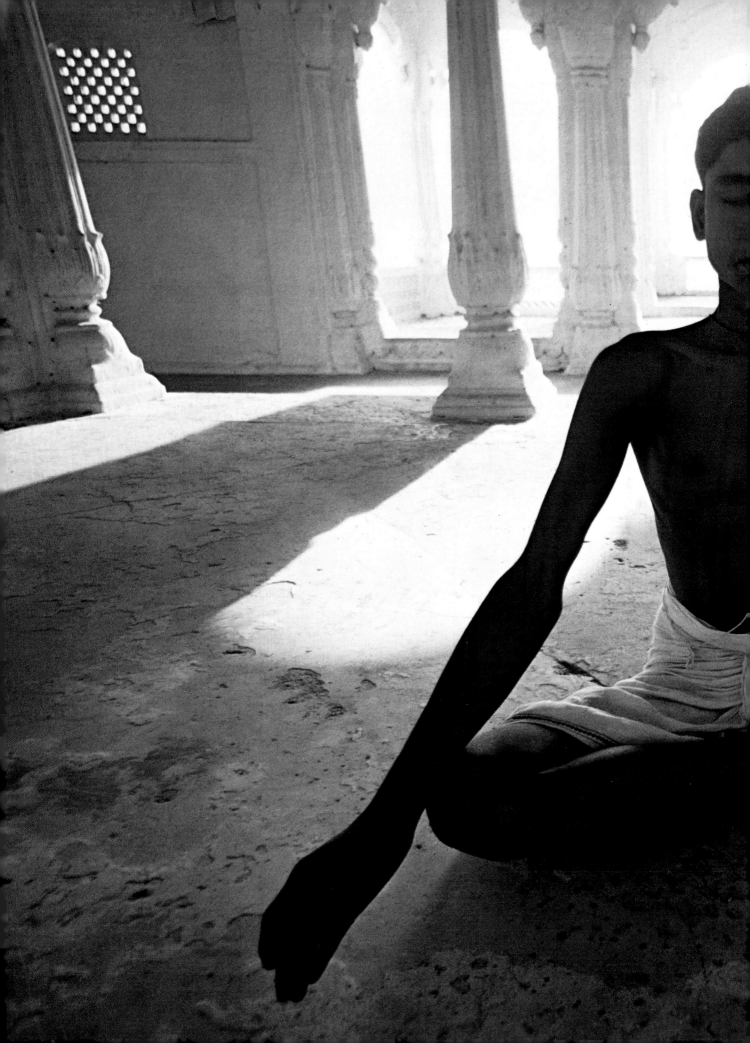

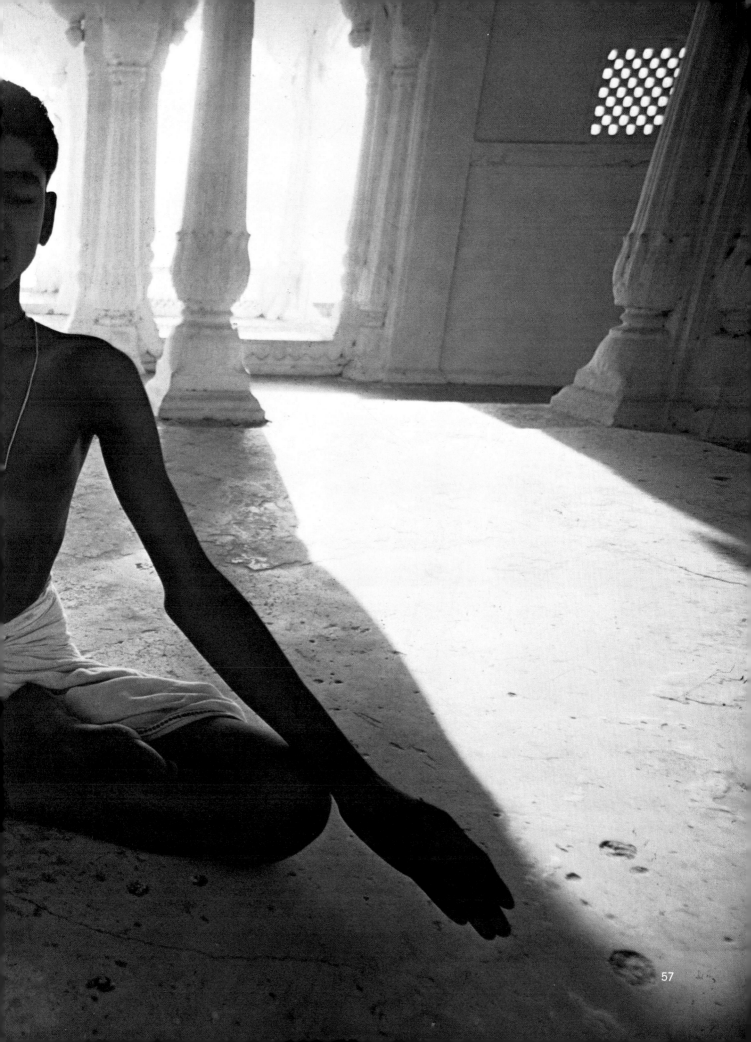

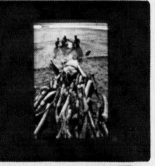

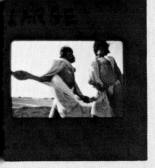

Translating a novel into pictures

The lines of the dark-skinned youth's face were drawn into a frown, his features a picture of glum disappointment. McBride

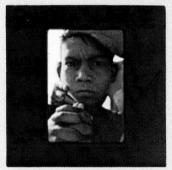

smiled happily as he focused on the boy and the older man who portrayed his father. "Perfect!" he yelled and nodded to an assistant, asking him to translate the word. Two days ago they had tried this same scene but the boy had been unable to muster a frown. Since that failure the youth had been practicing and McBride had often seen him scowling into an old mirror, working to master the exact expression demanded of him.

McBride was using actors, some of them professional, some of them amateurs selected from the streets. He coached each of them in the meaning of his or her part. From each McBride had to elicit a photogenic performance.

Hermann Hesse's tale

of a man's search for enlightenment had drawn McBride into a production that required his unflinching attention for six months, outlays of his own money and *Twen's,* a cast of 20 and a crew of a dozen, and a daily grind that combined with the Indian sun to melt 20 pounds from his already thin frame.

He proposed to illustrate *Siddhartha* in 70 scenes. After preparing a shooting script and sketches for each one, he borrowed production assistants from Satyajit Ray, India's most noted filmmaker, and combed the streets of three cities for actors and locations before settling on Benares. The resulting essay followed the words of the book as a movie follows a script, in a progression of images that McBride considers his most successful and important work to date.

During the month and a half that he spent in India, McBride ran into a chain of unexpected troubles. Religious and social taboos prevented the shooting of many photos he had anticipated. Expenses mounted fast. Envious villagers fought for jobs with his crew and on one occasion a shooting session ended abruptly in a near riot; some assistants holding strobe lights on long bamboo poles were attacked by a crowd that had grown furious when it saw McBride photographing an idol. When his money ran out, McBride found he had completed only 40 of the 70 planned scenes, covering them with nearly 10,000 transparencies. A few are shown at the left, spread on a light table for preliminary viewing.

Will McBride's "Siddhartha," first published in *Twen,* made its way to an international

audience through the pages of *The Sunday Telegram* (England), *Look* (U.S.A.) and *Zoom* (France and Italy). "It really hit and influenced a lot of people," McBride says with satisfaction.

"The story of a young boy leaving his home and father and disregarding tradition added up to what I had experienced and what I wanted to do. I was that person." McBride himself designed the flow of pictures for the 40-page layout that appeared in *Zoom;* to see how he arranged it, you can look at the entire essay, reduced in size, on pages 60-62. To give some idea of the impact the photographs made in the magazines that published them originally, several are reproduced full-size on pages 56-57, 63, and 64-65.

Each photograph was a major production in itself, requiring assistants to carry storyboards and props, supply makeup and translate instructions, handle flash units and light reflectors that McBride used to fill in shadow areas, all of them vying for the favor of the photographer in the dhoti. It was the way McBride works best, but anyone who wants to illustrate a book or short story could follow his scheme in less elaborate form.

By contrast to all those complications, McBride exercised utter simplicity in his approach to lenses. He shot "Siddhartha" entirely with wide-angles, using their bending of perspective to emphasize his feelings for the characters and the story.

"Using wide-angle lenses as I generally do," he explains, "involves a lot of forward movement of the photographer's body. That is, once I have dashed around fighting with life, crowds, with the models, with the camera

SIDDHARTA

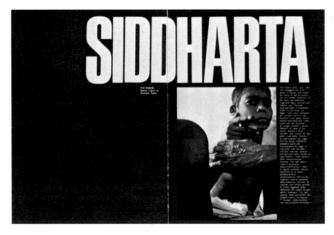

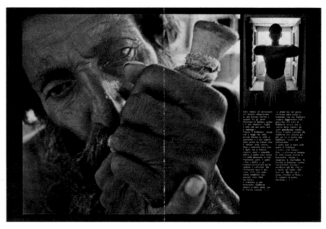

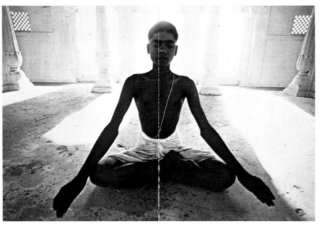

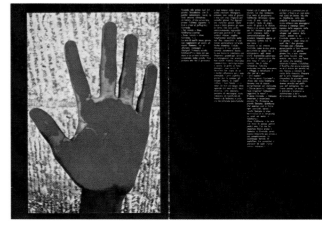

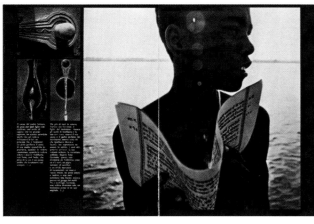

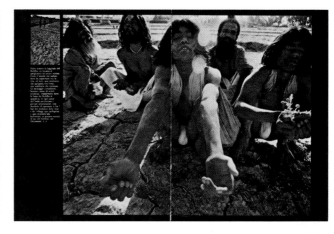

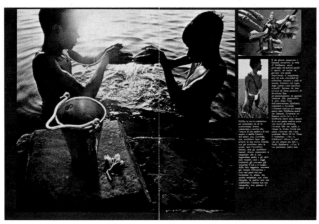

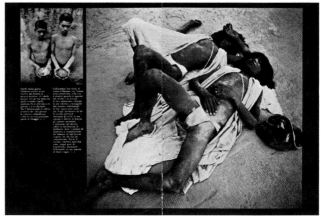

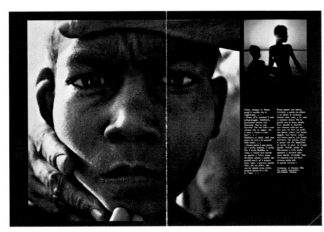

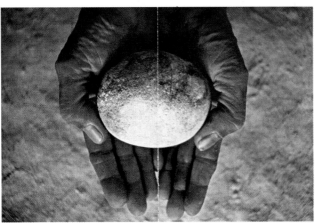

angles, with my own fear and fatigue, and place myself about right to the subject, then the very, very small movements of my body—a centimeter or two—are important. A wide-angle lens makes foreground objects very imposing, and a slight movement of the camera up or down, to the right or to the left, can clear whole streets, buildings and large crowds, getting rid of lamp posts and power lines that do not contribute to the telling of the story."

McBride often works close to the subject. "**The closer you move in, of course, the more you blank out the background with the subject's body.** But wide-angle lenses keep a large amount of background information still in the picture *while* maintaining a large amount of emotionally packed foreground." To work within a foot or 10 inches of a subject and frame as precisely as he does, he prefers to use a single-lens reflex camera; the viewing system operating through the lens tells him exactly what elements he is going to get on film. Even for studio work, he usually

sticks with 35mm cameras like the Pentax Spotmatics he used in India, since their lightness and ability to accept a wide range of lenses let him move and shoot freely.

He worked carefully with the special properties of a 20mm wide-angle, for example, to make the picture on pages 56-57 of the young Siddhartha in meditation. He had found an ideal temple for the picture; it was, in truth, very small, but he knew the lens would not only include large amounts of "information" but would also magnify an illusion of depth to make the place look larger than it was. A careful check of the location revealed that the rays of a rising sun would make the pattern he wanted. He coached the actor playing Siddhartha on how to sit in a modified lotus position and then made the picture with natural light, using white sheets as reflectors to bounce some light back onto the subject.

The hands and forearms, being closest to the lens, seem elongated. Since the camera was almost square-on to the pillars in the center, their vertical lines run fairly true. Pillars farther out, however, lean away because the curvature of a wide-angle pulls any image toward the corners of the frame, so the overall effect is to pull the eye to the center foreground of the picture— just where McBride wanted it.

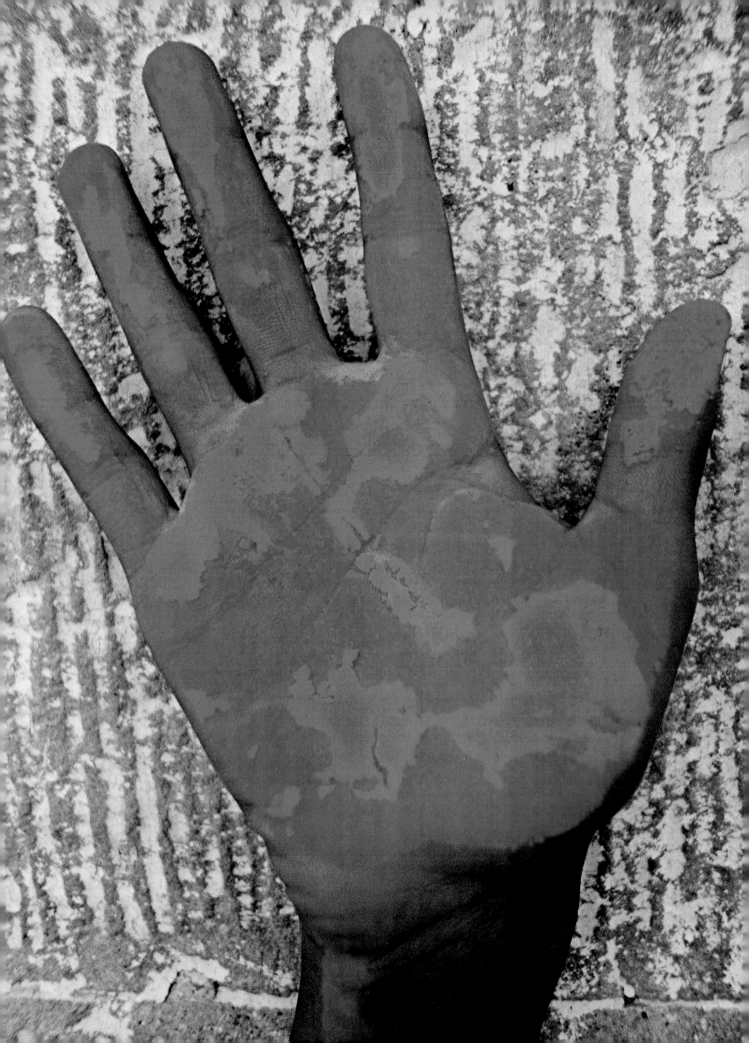

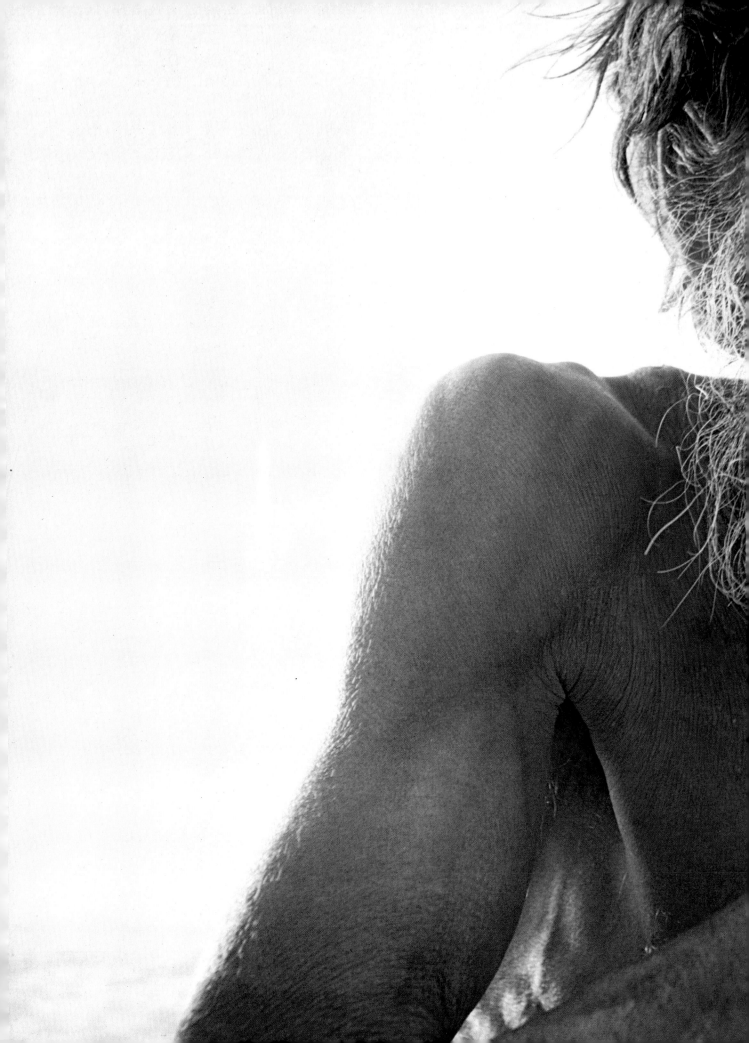

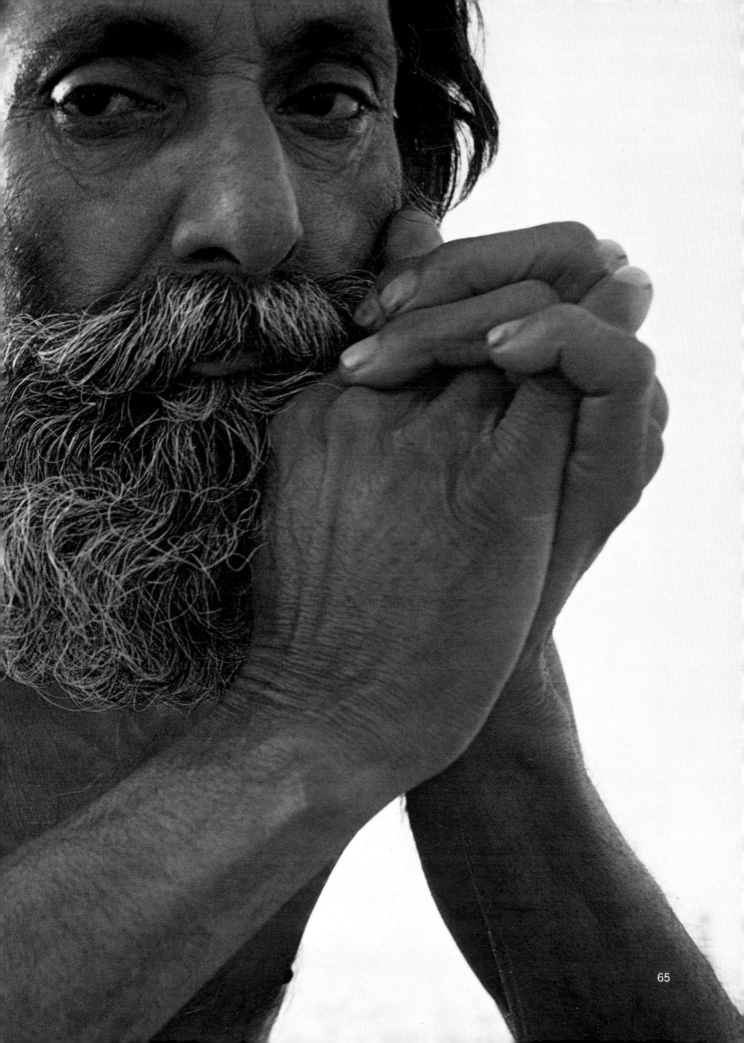

Selling a point of view

Twen's folding in 1972 intensified some doubts McBride had once again begun to entertain about his interest in still photography. Perhaps, he thought, movies would offer more potential for deep emotional involvement and impact on big audiences. He began making Super-8 films and worked on plans for a magazine he wanted to publish himself, a multimedia journal to be called *Jetz*—German for "Now." The cost of movie equipment, film, processing and editing quickly devoured his cash reserve. He had driven away his last advertising account, and there was

no more income. Without money for even the rent, he closed up the Munich studio and packed what he could into a Volkswagen van.

After several months of wandering, picking up assignments from *Stern* and other magazines, he headed for Italy, where he settled—for how long, he isn't sure—in a farmhouse near Lucca.

A coincidence, perhaps, but perhaps not, is that he went to territory where he had composed one of his lush ventures into fantasy, an essay for *Twen* that shows a happy group of young people exploring the Italian countryside without a worldly care. The essay, shown in part here, is quite frankly designed to sell something: the joys of the earth. Like the director of any television commercial, McBride collected a cast of models who looked as he thought they should, told them the concept—"We're going to urge people to climb away from apathy and try new pleasures"—and gave each of them a part to play. He then turned them loose and followed them, much as Paul Fusco did with his own children for his Seventies essay. McBride did more suggesting of situations than Fusco, but he photographed his models on the run with three 35mm cameras, sometimes using a wide-angle lens to get in close, sometimes using a telephoto to bridge distances, always looking for ways to use natural light, fog, buildings, to set his fantasy in a seductive beauty designed to lure the uncommitted.

"Sure," he says of this essay, "I'm trying to *move* people, in every sense of the word. I want to touch their emotions and change them."

The seductiveness is often steeped in eroticism. McBride aims to appeal to the senses, pushing erotic feelings as a natural part of life, a bridge between our physical and emotional selves. The carefree naïveté of his settings keeps it all innocent, ideal, perfect, unblemished—as you might

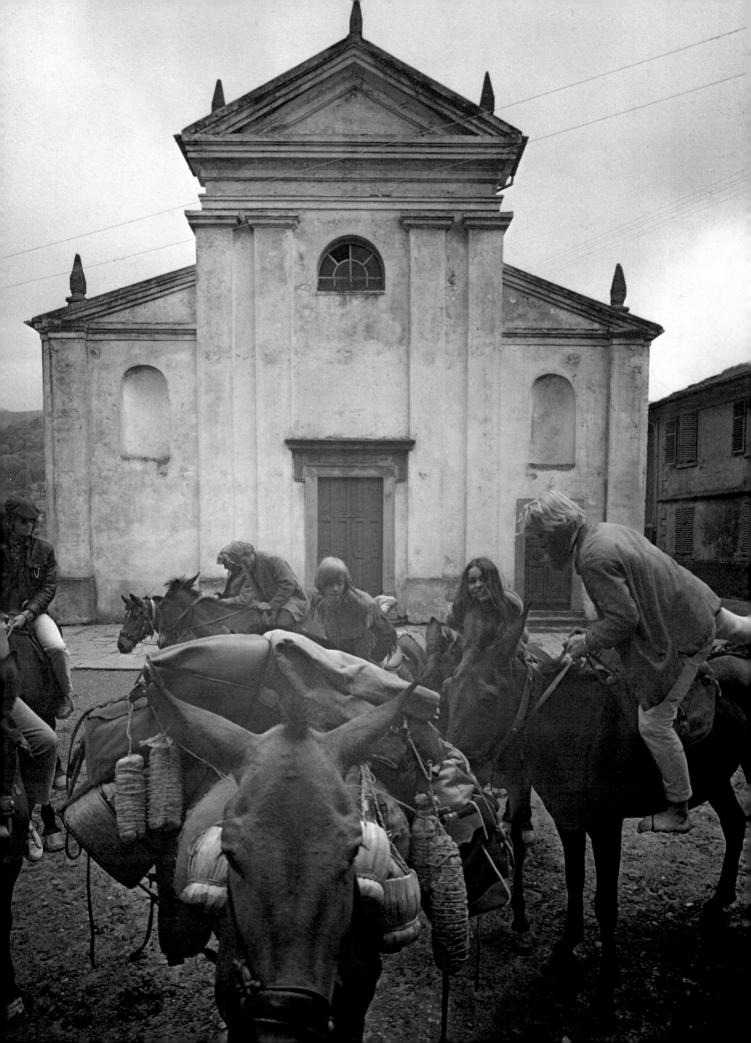

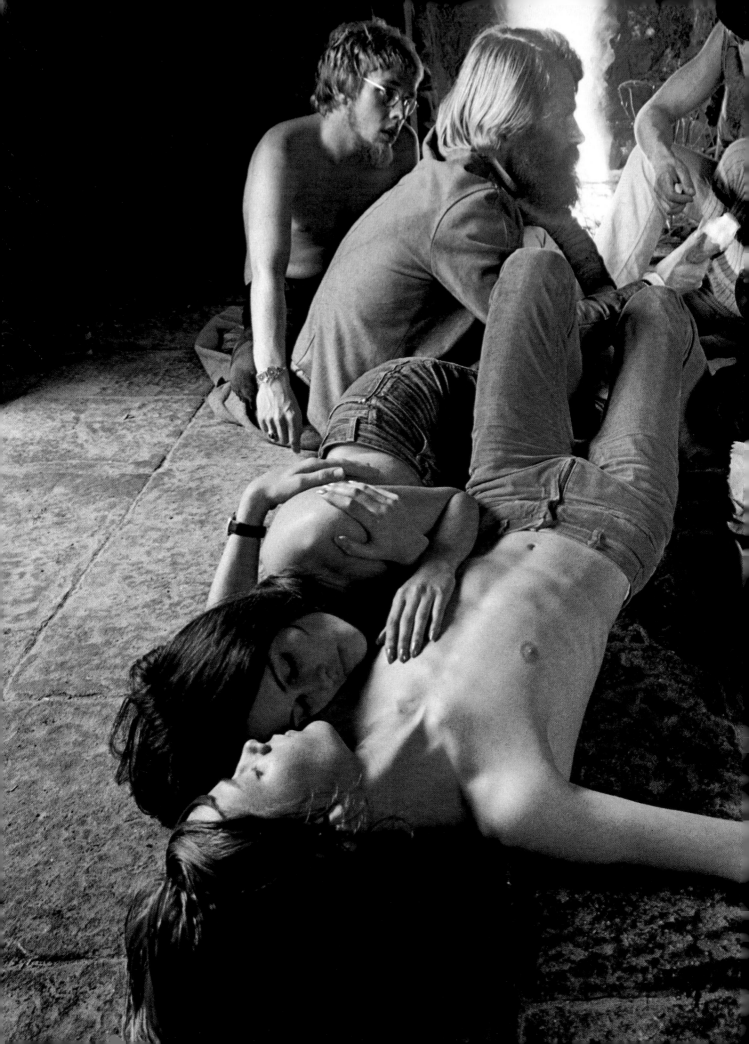

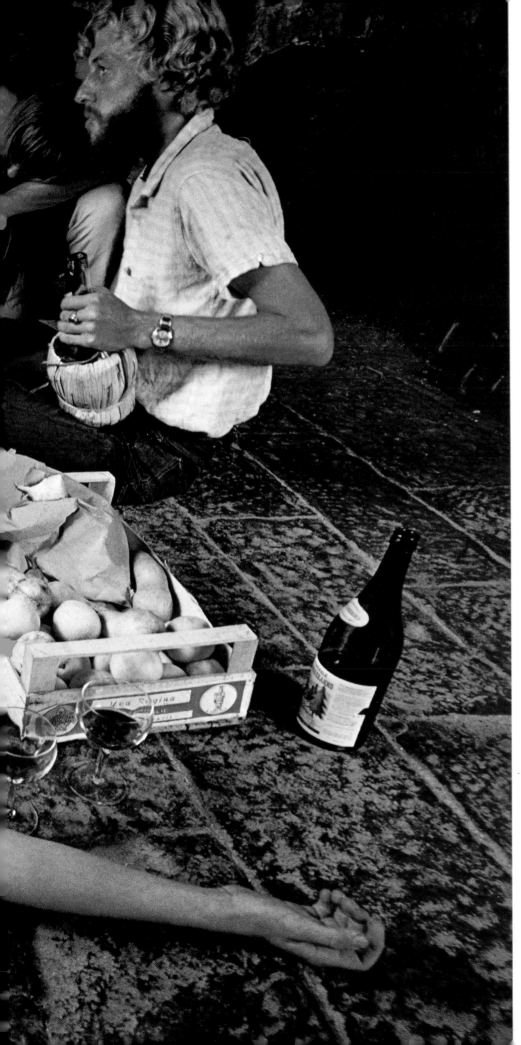

expect of a photographer who makes himself the hero of his work.

The sex, the freedom, the unburdened movement of the actors in such fantasies do, however, make a little trouble. McBride sometimes feels a twinge of jealousy between the self he projects out in front of the camera and the self that has to stay behind it pressing the shutter release. To keep his vision clear, he might have to rest periodically, stow away the cameras and recharge creative energies.

He has days on which he talks about resting, gardening, painting and working on his sculpture, but avoiding photography, "It occurs to me very strongly at this point in my life," he said recently, "that I have to stop taking pictures. I've heard about it happening to others and it has certainly happened to me. You get to a point where you have just filled yourself up with images and you don't want to look any more, and you don't."

He turns from a window that looks out to terraced hills, outcroppings of rock and gnarled old olive trees, and the Mediterranean far in the distance. "A photograph, or a whole essay full of them, can be a disappointing thing for me because it's not like the experience itself was," he says, running his fingers over the cold surface of a male torso chiseled in stone. "You can *describe* an experience in so many ways.

"What is so difficult is this business of trying to get other people to go out and have a similar experience. If you don't get other people to move and do the thing you're telling them about, then you haven't achieved very much, I don't think."

In another room of the house are his cameras.

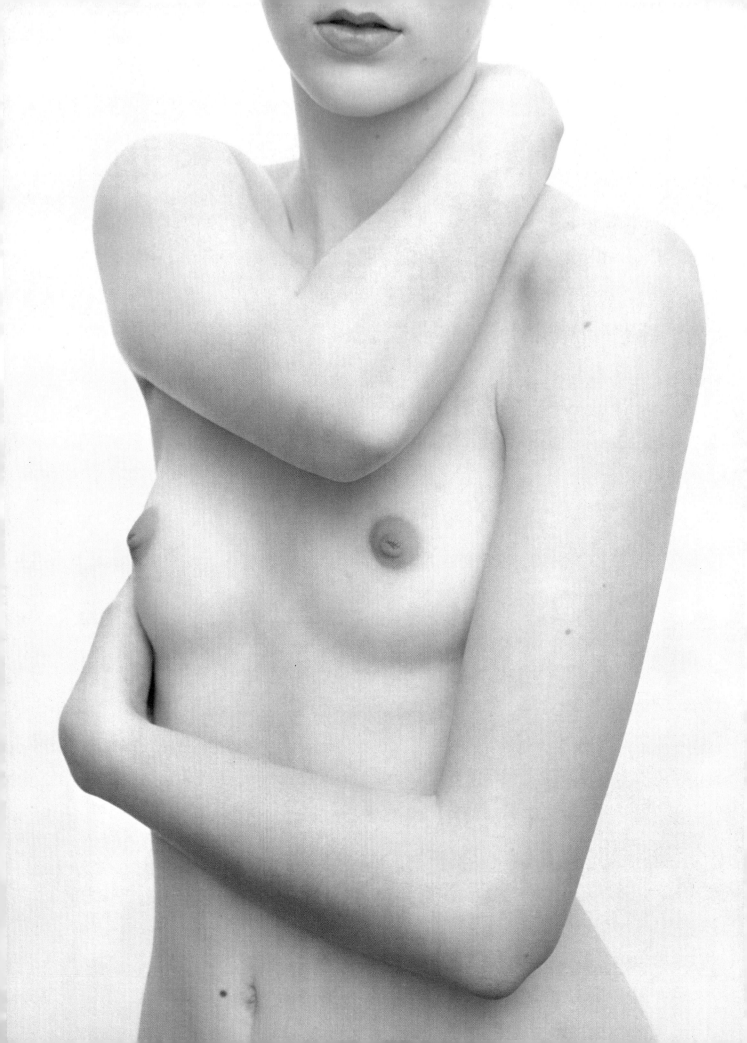

Technical section

THE APPROACH

Every photo essay obviously begins with an idea. It can be generated by the photographer, a friend, a writer, an editor or an art director, but often it emerges from a pooling of several individual talents.

There are few ideas, if any, that cannot be represented visually, though some might take a great deal more planning and manipulation than others. In any case, the essayist aims to flesh out the idea by making a series of photographs that, when interwoven, will enlighten or move a viewer.

Whether a professional essayist is considered to be primarily a journalist or an illustrator, the germ of the idea can come from a news event (as in Paul Fusco's *La Causa*), a combination of social commentary and visionary themes (as in Will McBride's *The New Man* and Fusco's *George's Branch, Ky.*), or a single personality of great interest (McBride's *Adenauer* and Fusco's *Diana Ross*). An amateur can look to family, vacations, friends, neighborhood, and other subjects of special importance, and then arrange pictures in an album in exactly the same way a professional might arrange them in a magazine.

From the beginning of his career at *Look* magazine, Fusco would spend his early morning hours

From a series of Clearasil advertisements by McBride.

reading the New York *Times* from cover to cover. One of the things he was looking for was news items that could become picture essays. In 1968 he read an article on a Kentucky coal-mining company that was automating and cutting down its payroll. The plight of the unemployed coal miner was a subject about which Fusco felt deeply. He based his presentation of the idea to his editors not only on his personal interest but also on the relevance of the theme to the current American situation. Two days later, a writer was assigned to accompany Fusco on the project that produced the essay on George's Branch (pages 40-47).

Will McBride and Willy Fleckhaus, *Twen* magazine's art director, spent many hours discussing the ways in which they saw society changing and their ideas about contemporary attitudes and mores. In the course of one of these conversations, Fleckhaus gave McBride a copy of a novel that was enjoying tremendous popularity among young readers, Hermann Hesse's *Siddhartha,* and before the photographer finished reading it he had begun sketching picture possibilities in the margins. McBride was convinced that he had to illustrate the book's message photographically. Fleckhaus agreed, with a canny eye on his magazine's youthful audience, and McBride was soon on his way to India to work on a complex essay that bears his strong personal stamp (pages 60-62).

Once a suitable subject has been selected, the photographer must decide on an approach that will most strikingly illustrate his discoveries and his feelings about them. There is no standard personal or technical approach, no pattern that will always work. Each situation generates an approach that suits what the photographer wants to say.

The able photographer must see what is unique about his subject, analyze the circumstances and the action taking place before the camera, and decide on a way to transmit them to a viewer. Of the many ways to look at a complex experience, the seasoned professional usually finds one that sums up the truth of the situation as he or she sees it.

Fusco prefers an open approach, working from a base consciously devoid of preconception, gaining his understanding by observing subjects as he photographs them. He develops a thematic structure and does much of his research while he works with his cameras.

McBride is most comfortable studying the theme he will work on before he actually begins photographing it, sketching out picture possibilities, designing a shooting script, detailing needed props, actors and makeup before he picks up camera or light meter.

Yet a measure of the success of both these photographers is their versatility, their ability to adapt an approach to the subject at hand, to concentrate on organizing an essay that illuminates the subject instead of obscuring it, and to speak with distinct visual impact.

In order to translate these concepts into photographs, the first and most important consideration for both Fusco and McBride is an understanding of the tools and techniques at their command.

THE IMPORTANT OPENING PICTURE

The most important photograph in any essay is the one designated as the "opener" or "lead" picture. A photographer engaged in a photo essay or picture story searches constantly for the one image that will:

• Intrigue the viewer, attracting intellectual and emotional interest to the story, and

• Introduce the viewer immediately and succinctly to the theme and major elements of the story.

Many of McBride's essays deal with abstract ideas, subjects that do not lend themselves to a linear progression of narrative pictures. He therefore finds it especially important to make an initial photograph that is graphically strong and dramatic enough not just to capture the viewer's attention, but also to prepare for subsequent exposition and sub-themes.

McBride's opening photograph for the essay called *Der Neue Mensch* is an excellent example of a powerful opener. The theme of the essay centers around the new perceptions, attitudes and life-styles of young people. They live in a world that many perceive as more complicated than it was in the past, and McBride wished to show how they might come into harmony with it through simplicity and independent values. As he sees it, the most staggering of the many aspects of modern life is its reliance on technology. People who begin to feel overcome by mechanization and supercomputers begin to fear they are losing control over their lives. McBride sought to allay those fears with an image suggesting that technology, being a product of human intellect and creativity, can harmonize with humankind itself.

McBride used a television set to symbolize the products of modern technology, and decided to cradle the small-screen receiver in the arm of a man whose physical strength would seem to overwhelm any threat the TV might offer. On the screen, an eye serves as a reminder of the humanity behind technology. McBride used a portable Sony TV camera to transmit the image of the eye to the screen, focusing

the closed-circuit camera's zoom lens on a female model on whom he had trained a floodlight from the side. The transmission was live, simultaneous with the taking of the still picture.

McBride placed the male model holding the TV set in front of a spun-glass screen that he uses frequently to form a luminous, diffused background in the studio. A single electronic flash, behind and very close to the translucent spun glass, provided a soft light that was strong around the head and upper torso and then fell off rapidly into darkness. A second strobe, aimed into a reflector umbrella, was placed directly behind the still camera and aimed downward from a height of about seven feet to provide frontal illumination.

In retrospect, McBride feels the lighting on the eye could have been simpler, with the floodlight at the front, instead of the side, to tone down the abruptness of the shadows.

To synchronize the exposure with the rate at which a TV electron gun constructs an image as it scans lines on a screen, McBride used a shutter speed of 1/30 second — "or maybe even 1/15 second in this case" — stopping the lens aperture down to f/8. The camera for this picture was a Pentax Spotmatic equipped with a Zeiss Jena Flektagon 20mm wide-angle lens that served to emphasize the breadth of the male model's shoulders and the bulk of his arms, subduing the power of the technological symbol.

As we will see later, McBride admired the opti-

cal qualities of the Flektagon — an East German lens — but no longer uses it because it was so fragile that it kept breaking. He used the single-lens reflex Pentax to take advantage of its through-the-lens viewing and focusing, because the composition of his close-up pictures is often so precise that he cannot afford even the slight parallax of a rangefinder camera. The difference between the view of an object as seen through the picture-taking lens and the view as seen through the separate rangefinder could throw off his framing by crucial inches.

Fusco operates differently, of course, when reporting on lives that he intends to show as they were before he arrived. Still, the importance of the essay's opening photograph can bring him out of hiding, no matter how much he wants to avoid interfering with his subjects.

Fusco tried to be as unobtrusive as he possibly could while doing his essay on George's Branch, yet in his quest for an opening picture he had to ask Mary and Rado Combs to pose for him. Looking for "a Grant Wood squareness and symmetry," he asked them to stand by a window in their house for a portrait

(page 40, inset). Here he used his 180mm lens on a Nikon F, from a distance of about 30 feet. The ground dropped off below the window, so he had to back up to a rise in order to stand nearly level with the subjects; a shorter, wider-angle lens would have included too much surrounding detail and destroyed the simplicity he wanted to use in setting the emotional tone for the remainder of the essay. Fusco used the Plus-X film that he always uses for outdoor black-and-white work, overexposing by half a stop to make sure he got good shadow detail in the faces and bodies behind the glass, where he expected the light to fall off. His exposure was 1/125 second at f/5.6.

THE TELEPHOTO AS A TOOL

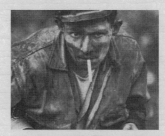

Individual photographs in an essay must complement each other, each adding to the narrative and emotional impact of the

others. Yet each can stand as a dramatic picture, an individual statement, in itself. Paul Fusco's photograph of a young miner waiting for his wife (pages 40-41) is an excellent example.

When he saw the young coal miner waiting on the road below the house of his father-in-law, Fusco wanted the picture but did not want to destroy the emotional atmosphere by charging out the back door, circling the house and running up to his quarry. Instead, he slipped out the doorway onto a front porch and began taking photographs with a tool made for just such situations, a 180mm lens. The miner, again some 30 feet away, paid scant attention to the photographer and Fusco was able to capture the anxiety and fatigue emanating from the man. He used a shutter speed of 1/250 second, fast enough to avoid softening the critical sharpness of the image with camera movement— one of the great hazards of telephoto lenses.

Long focal-length lenses contribute to the essayist's versatility. If Mahomet—or Fusco or McBride—cannot go to the mountain, the telephoto can bring the mountain to him.

Fusco used the telephoto again in the tableau combining a trio of United Farm Worker pickets with a mobile shrine in the greyness of an early morning fog (pages 32-33). The purpose here was manifold. By putting distance between himself and his subject matter, he shot through more layers of fog than if he had stood close, and therefore emphasized the lonely, quiet mood he felt in the moment. Also, the long lens "flattened" the planes of the picture by compressing front-to-back perspective, adding to the symbolic, almost icon-like quality of the composition.

The advantages of the telephoto lens do not come without the need for care.

Generally speaking, the longer the focal length, the longer and heavier will be the lens itself, and the greater the necessity for discipline in camera technique. Camera steadiness becomes imperative. Since the 180mm, f/2.8 Elmarit that Fusco uses has an angle of view of only 14 degrees as compared to the 46 degrees of a 50mm lens, a slight movement of his camera could be translated into the equivalent of several feet of movement by the subject—and as much as one-eighth of an inch on the film plane. It goes without saying that the result would be a blurred image.

Because of this, some professionals use tripods or special shoulder-chest braces to insure themselves against camera movement when using extreme telephotos. Up to 180mm or slightly longer, however, Fusco usually hand-holds.

Since longer lenses have less depth of field than short ones, they can be used to isolate a prime subject from its surroundings. By focusing sharply on the subject and working with as wide an aperture as possible, a photographer can throw foreground and background out of focus, thus subjugating distracting or meaningless elements into inoffensive blotches and blurs.

Another ideal use of lenses longer than the "normal" is portraiture. Will McBride used a 90mm telephoto for his tightly cropped candid portrait of Konrad Adenauer on pages 84-85, and for his posed portrait of a young Indian woman in profile (bottom left, page 61) for his *Siddhartha* essay.

The latter photograph, made in an improvised studio in Benares, India, was lighted almost identically to the photograph of the male model holding a TV set that led off *Der Neue Mensch*, except that the backdrop was an orange sari draped from a horizontal bamboo rod several feet away from a white wall. McBride put one Braun Hobby Strobe behind the cloth; another bounced light onto the front of her profile from a white umbrella behind and slightly above the camera.

McBride, of course, uses long lenses much less frequently than Fusco. His true dedication is to the wide-angle lens, as you can see by studying his *Siddhartha* essay.

THE WIDE-ANGLE AS INTERPRETER

Will McBride's visual interpretation of Hermann Hesse's *Siddhartha* was an undertaking almost as massive as a motion picture production. In pursuit of the photographs he had visualized for the story, McBride shot thousands. With very few exceptions, all of them were made with wide-angle lenses varying only four millimeters in focal length: the 20mm and 24mm Jena-made Zeiss Flektagons, lenses that are no longer obtainable.

McBride learned to swear by, and to swear at, the Flektagons. He loved the fact that he could move in as close as 10 inches to his subject when focusing and that, for wide-angle lenses, the Flektagons' linear distortion was minimal. Nevertheless, he found them to be extremely delicate; their moving parts broke easily, so he had to buy three lenses at once to be sure he had one that was working whenever the others fell apart.

After *Siddhartha* he gave up on the fragile Flektagons and has switched over completely to the products of Ernst Leitz; his lenses are Summicrons, Super Angulons and Elmarits, fitted to Leica and Leicaflex bodies. McBride recognizes that lower-priced equipment would last the lifetime of most amateurs, but knows that professional use and abuse makes top-grade equipment not a luxury but a necessity for him.

Whether the optics come from East German Jena glass, from the "rare earth" of Japan, or from Wetzlar in West Germany, all photojournalists and photo essayists rely heavily on wide-angle lenses. They often need an angle of view that can be as wide as 94 degrees for a 20mm lens or 81 degrees for a 25mm, compared to the 46 degrees of the standard 50mm. Coupled with such peripheral vision is the wide-angle's great depth of field—which, among other advantages, relieves the

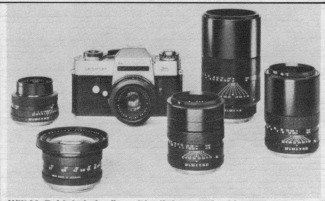

Will McBride's Leicaflex with all the standard lenses
The Leicaflex SL and six of its family of R lenses. From left to right: 35mm f/2.8 Elmarit-R; 21mm f/4 Super Angulon-R; 50mm f/2 Summicron-R (on camera); 90mm f/2.8 Elmarit-R; 180mm f/2.8 Elmarit-R; and the 135mm f/2.8 Elmarit-R.

General Uses of Telephoto							
Type of Photography	Telephoto Lens						
	85	105	135	180/200	300	400	600
Portraiture	■	■					
Sports/Action		■	■	■	■		
News Coverage			■	■			
Theatre			■	■	■		
Landscapes					■	■	
Wildlife					■	■	■

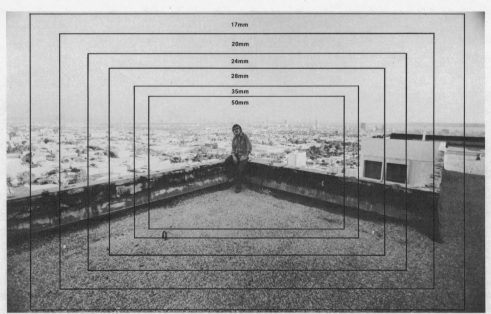

The fields of view that lenses of differing focal lengths cover at a distance of 25 feet from the subject.

17mm
20mm
24mm
28mm
35mm
50mm

photographer of some focusing problems. Once a wide-angle is focused on a subject 10 feet away, for example, with the aperture set at mid-range, re-focusing is almost unnecessary unless the subject moves many yards.

"The simpler the technique I use," McBride says in this connection, "the nearer I am able to stay to the things going on and the more I can concentrate on the revealing of truth and the relating of experiences." As he has said in talking about the shooting of *Siddhartha*, the use of wide-angles draws him into the picture in a way that involves a great deal of forward movement of his body; not only is he moving in toward the subject, but he is also adding or subtracting elements with these slight changes of position.

While telephoto lenses tend to compress space, almost eliminating the illusion of dimension in a photograph, wide-angles work the other way around—they magnify apparent depth. Objects in the foreground seem to project themselves toward the camera, while

those farther away shrink away. The resulting visual effect can help a photographer create dramatic sculptural compositions.

An excellent example of the unique characteristics of the wide-angle is the photograph on pages 56-57 of the young Siddhartha meditating. McBride spent several days studying the many temples of the holy city of Benares until he found one that would be ideal for the picture he had in mind. After receiving permission to photograph inside the temple, he and his crew began to set up for shooting in the early predawn hours; a previous check of the location had shown him exactly how the rays of the rising sun would come through the windows behind his model, and exactly what pattern the light would make. He then used the extreme curvature of a 20mm Flektagon to emphasize the center foreground of the picture, both by making portions of the model's body seem to project forward and by making objects near the edges of the frame seem to lean away. The eye follows all these lines to the boy's center—which, for a Buddhist, is where it should go.

The kind of light a photographer likes to work with often influences his style

and the look of his pictures. Most photographers try to avoid the harshness of midday sunshine; beyond that, McBride shows a preference for soft daylight and seldom makes pictures in direct sun if he can avoid it.

When he could not shoot in early morning or late afternoon, he used other devices in *Siddhartha* to rid himself of raw sunlight that was not softened by clouds or haze. He shot in shaded areas, or at right angles to the light, or straight into it, using subjects' bodies to mask the sun itself from the lens.

The *Siddhartha* series shows some of the hazards that wide-angles bring to such shooting, as well as McBride's way of using them to his advantage instead of fighting them. In the photograph of the two boys in the water at the bottom left of page 60, the sun —outside the frame at the top—reflects on the water to cause a "flare-out" that destroys the silhouette of the boy at the left. At the top left of page 61, in a picture for which McBride used a 20mm lens to photograph two boys with three tiny men framed between the legs of one of them, the flare-out occurs over the right angle made by the knee even though the sun was out of the frame.

In both photographs, McBride used the flare to convey a feeling of heat and intense sunlight. A photograph on page 60 of Siddhartha holding religious scrolls shows another use for the flares that a wide-angle's curved glass tends to pick up. Here, the sun-spots grow progressively larger as they extend upward from the scroll, ending in a large spot of light in the middle of the model's head—a simple, direct way for McBride to suggest the progression of wisdom from one repository to another.

But flares are not always welcome. To avoid their ever-present danger when working outdoors with wide-angle lenses, both McBride and Fusco carry lens shades as important accessories. Each type of wide-angle requires its own specific shade; a shade made for a lens longer than the one to which it is attached will cut into the field of view, eliminating part of the photograph. Unless such "vignetting" is done deliberately, it has about the same appeal as a thumb over the lens.

DEPTH OF FIELD

One technique that both Fusco and McBride use to emphasize the things they find important in a picture is careful manipulation of the sharpness of objects at different distances from the lens.

A single-lens reflex camera allows a photographer to check this depth of field directly by pushing a "preview" button that stops the lens down to a preselected aperture setting and shows the area of sharpness in the pentaprism viewfinder.

The clear window of a rangefinder camera, however, does not offer such information; everything appears in sharp focus. While depth-of-field numbers are etched next to the focusing ring on all lenses, the numbers make sense only if a photographer un-

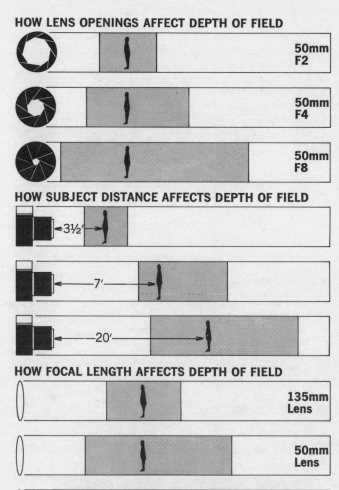

HOW LENS OPENINGS AFFECT DEPTH OF FIELD

50mm F2

50mm F4

50mm F8

HOW SUBJECT DISTANCE AFFECTS DEPTH OF FIELD

←3½'

←7'—

←20'—

HOW FOCAL LENGTH AFFECTS DEPTH OF FIELD

135mm Lens

50mm Lens

24mm Lens

derstands how depth of field can be affected by three factors: lens aperture, focal length of the lens, and distance at which the lens is focused.

This chart gives an idea of how depth of field changes with each.

BRACKETING

If Paul Fusco had to condense his advice on photographing in color to one word, it would be "Bracket!"

He shoots color at the exposure his meter tells him to, then at shutter speeds and f/ stops above and below it—not because he is unsure of what he is doing but because such bracketing is one of the few ways he can control the emotional information in a color picture. Given a black-and-white negative, he can work for hours in a dark-room to make precisely the

print he wants; he cannot do that with a color transparency. Once he presses the shutter release with color film in the camera, the only thing left to do is to drop it off at a lab for developing.

Bracketing does, of course, provide some insurance against varying light conditions, inconsistencies in meter readings, or variations in color-film emulsions. Beyond that, however, both Fusco and Mc-Bride know that the mood of a color picture can change drastically with very slight variations in hue and intensity. For Fusco, who shoots most often in situations where he does not control the light—only what he does with it—bracketing provides a chance to catch, perhaps on one frame of an entire roll, precisely the atmosphere he felt as the ex-

perience unfolded.

He bracketed every one of the exposures that went into his Seventies essay on the re-discovery of our natural environment (pages 18-25). He would take a meter reading and begin shooting at the indicated exposure. After clicking off several shots, he would move up or down a half-stop or a stop and continue until, in exceptional situations, the original exposure had been bracketed by as much as two full stops each way. He tends to bracket toward shorter exposures and smaller openings, since he leans toward underexposure and its increased color saturation on the transparency.

Bracketing can be done by changing the lens aperture, the shutter speed or both. Which to change? That depends on the sub-

ject matter and the aspect of the photograph that the photographer most wants to control.

Fusco's poetic seascape on pages 24-25 is an example of bracketing by changing shutter speeds. He did it that way not only to obtain different intensities of light as the sun set over the Pacific Ocean, but also to get different qualities of blur in the water flowing over the rocks. Wanting to convey his impression of the twisting, flowing channels of foam, he found himself working in one of those many instances in which an exposure meter could never tell him what to do.

On the other hand, he did his bracketing with the aperture setting for the photograph of the Mount Rainier ice cave on pages 22-23. The difference in meter readings from the

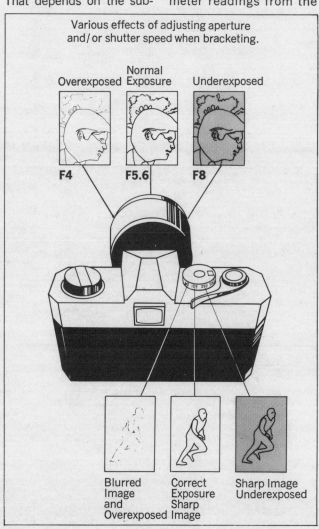

Various effects of adjusting aperture and/or shutter speed when bracketing.

Overexposed / Normal Exposure / Underexposed

F4 / F5.6 / F8

Blurred Image and Overexposed / Correct Exposure Sharp Image / Sharp Image Underexposed

dark interior of the cave to the sunlit clouds at its entrance was huge, so Fusco started from his highest meter reading, exposing for the bright background, and worked his way down the scale to a probable overexposure. He varied apertures to give himself a choice of color intensities and shadow details, keeping the silhouetted figures sharply outlined by adjusting his focus as the changes in aperture changed the depth of field. As a result, different frames showed different degrees of sharpness in the foreground; the transparency Fusco selected for publication retained sharpness from front to back, indicating that it must have been one of his smaller aperture settings.

PRINTING

When Fusco works in black and white, on the other hand, he knows that the process of creating a photograph might just be *starting* as he trips the shut-

ter release.

And creating it can be, almost as much as in the making of a painting. Black-and-white film gives any photographer a latitude in exposure and a flexibility in the darkroom that color positive transparencies cannot match. Some of today's best photographers owe their understanding of the possibilities in their pictures—of the dimensions, the depth, the expressive potentialities of a photograph—to their background in black-and-white darkroom work.

Why? Simply because a black-and-white negative in a darkroom finally escapes the machinery where it has been imprisoned behind glass, metal, springs and knobs. An amazing number of photographers who have not spent an apprenticeship in a darkroom see picture-taking in terms of cameras, lenses, the hardware that transmits an image to the eye—an image that they often perceive only dimly as a meter read-

ing and a shape or two.

While the film is in the camera, a photographer can manipulate light only in a crude way, by letting more of it or less of it through the lens. He cannot reach in and hold his finger in front of a portion of the frame to subtract light from a too-bright face, say, nor can he expose just one dim corner longer than the rest of the frame. When the negative enters the darkroom, however, all those limitations fall away. The photographer can interfere with the light shining through his negative in the most minute, intricate, subtle ways, one square millimeter at a time if he wants.

When Fusco took the picture of Rado Combs' daughter and her miner husband walking up the curving road (pages 46-47), he knew he would not be finished with it until long after the shutter clicked. From the moment he aimed his camera at the couple, he knew the picture would require a great deal of darkroom

work to make it say to a *Look* reader what the scene said to him, but he could not sacrifice the shot. The road, the curve in its path, the bend in the miner's backbone, the set of his wife's shoulders, all indicated to Fusco an endless path, a journey with no rainbows in sight.

The hues of the dirt road and the vegetation surrounding it could have stood out from each other on color film, but Fusco's eye—trained in years of converting color mentally to the grey tonal scale of black-and-white film—told him that the color-blindness of the Plus-X film in his camera could make no distinction between these hues. They would register as very similar intensities of grey. At the moment, there was little he could do about that. He decided to

Notes for making a print on multi-contrast enlarging paper, using different filters to bring out contrast.

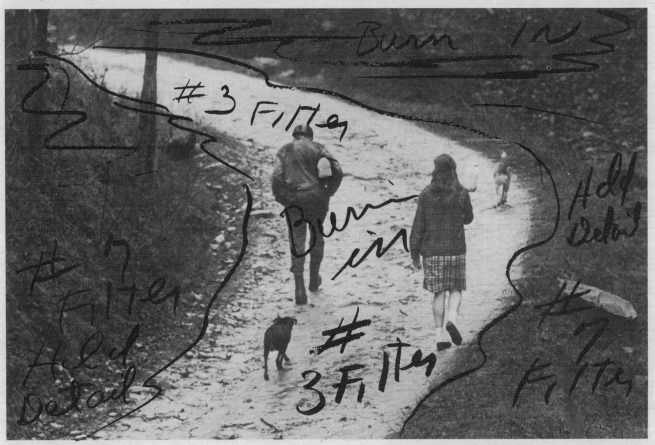

78

expose for the darkest areas, to hold detail in the shadows. If he had exposed for highlights (the road, in this case), the shadow areas would have gone almost black, blocking out detail. His exposure gave him something on the negative to work with. If detail exists, you can labor over a print to preserve it; if it doesn't, there is nothing you can do to put it in.

Fusco, like any other photographer working seriously in black and white, has learned to evaluate pictures in shades of grey before opening the shutter. With foreknowledge of what the final print will look like, he can make compensations on the all-important negative from which the print must be made. As he aims the camera, he has two alternatives: to vary exposures, or to use filters to lighten or darken specific areas. Judgments made at this point can save hours of darkroom time.

Even with advance knowledge of the problems of merging greys, a photographer frequently has no chance to select the proper filter and attach it over his lens; the instant available to him has to be devoted to exposure calculation, focusing and framing. As a photojournalist, Fusco seldom has time for filters, and he did not on this afternoon in Kentucky. To bring out the precise separation in tonal values he wanted in the figures on the road, he later spent hours in the darkroom, working on the print.

Before he started, Fusco had added yet another decision to his long list of choices: the type of photographic paper on which he planned to make the enlargement. He had basically two types from which to choose: graded paper and multi-contrast paper. Each type gives the photographer a different kind of control over the contrast—the range of tones from bright whites to deep blacks—in a picture.

Graded papers, usually numbered from No. 1 to No. 6, have emulsions that produce predictably different amounts of contrast in prints, depending on the grade used. The higher the number, the higher the contrast across the entire print made on a sheet of that paper. Had Fusco tried to print his low-contrast negative on a sheet of No. 1 paper, the result would have been a blob of almost uniform grey, with no highlights and no shadows. A "normal" print comes from balancing high and low contrast, so he might have tried printing on No. 4, 5, or even No. 6, all considered high-contrast papers; but as he worked his way up the scale, he would have produced increasingly harsh effects that did not fairly represent the melancholy light of the moment he had recorded. Besides, he saw several different contrast ranges within the single negative. No single grade of paper could handle them all.

The multi-contrast paper to which Fusco turned has not one emulsion on each sheet but two—a high-contrast one and a low-contrast one. Each responds to a different color of light coming from the enlarger. A set of special filters allows the photographer to produce different blends of the two colors, thus producing several different grades of print contrast on a single sheet of paper. Working on duPont Varigam, one of a number of brands of multi-contrast paper on the market, Fusco used different filters for different sections of the print, exposing small areas at a time on the enlarging easel. He "dodged" areas that were too dark, one section at a time, and "burned in" lighter areas such as the road to keep good detail.

Burning and dodging require only the simplest tools. For burning, Fusco usually cuts a hole in a piece of cardboard, then holds it under the enlarger so that extra light strikes the paper through the hole just where he wants the image to be darker. For dodging, he withholds light from part of the image with a solid piece of cardboard, or with his hand. In either case, he keeps the burner or the dodger moving so that its silhouette does not show up in the final print.

"The reason for spending all that time printing," he points out, "is not so that somebody will say, 'Wow, what a nice print!' Most of the people who look at the picture don't know a thing about printing and couldn't care less, and that's fine. But they see *something*, and they get a certain emotional punch from it, depending on how well you have made the print transmit the information you want it to. You have to control the print the same way a painter controls a painting, control the total surface." Using another analogy, he adds, "Taking a good picture and then not bothering to make a good print gets in the way of what you're trying to tell people; it's like saying, 'Well, I could have a great poem here but I don't feel like rewriting it.'"

THE ART DIRECTOR

But how do all those individual pictures find their way onto a printed page where they can interrelate with each other and tell their story?

Fusco's experience as a staff photographer at *Look* was quite different from McBride's at *Twen*. The two organizations had different personalities: *Look* was an informal, highly collaborative system in which photographers, writers, and art directors worked together to contribute to a statement

Will McBride's final layout for his children's sex book.

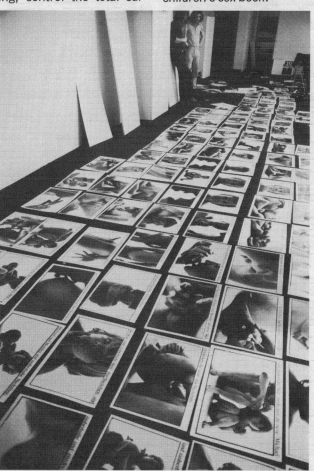

they all had a hand in, whereas *Twen* was more an autocracy run by the art director alone. While Willy Fleckhaus' power at *Twen* was unusual—he could arrange to have editors fired—the feeling among photographers today, since the folding of big staff-oriented picture magazines such as *Life* and *Look,* is that it is getting more and more difficult to retain control of essay layouts; perhaps the major area in which a photographer still enjoys the give-and-take that Fusco knew at *Look* is in book publishing.

When Fusco finished an assignment for *Look,* he would return to the magazine's offices and await the processing of the film. When the contact sheets (for black and white) or transparencies (for color) were ready, he would begin scanning images, doing his preliminary edit of a "take" that might amount to a hundred or more pictures for every one that would even-

McBride and assistants review first layouts of a newspaper he intends to publish.

tually be printed.

Then, if he was working with a writer who cared enough about the pictures to want a say in how they would be used, the two would join forces for further editing. The writer might bring his or her own needs to the process, judging the story-telling content of the pictures with an eye to the way they would work with the text being drafted; perhaps Fusco and the writer would disagree on the esthetic or narrative quality of one picture or another. Eventually, they would compromise, narrowing their "selects" down to 50-150 images. If they were in black and white, Fusco would then order 5x7 working prints, enlargements on which no remedial printing work would be done. If the selects were in color, he would load them into a Kodak Carousel tray, ready for projection.

At this point, the art director—Allen Hurlburt in Fusco's early days at *Look,* Will Hopkins later—would enter the scene. The three partners in the essay would go over the selected images, with Fusco and the writer

explaining them to the art director as they went along. Again, the selection of images to run in the magazine was a matter of debate; each of the three expressed viewpoints based on personal reactions to each picture and personal judgments of which combinations of pictures would serve the essay best. The final culling of the take might leave 10 to 20 photographs. It then became the art director's job, with Fusco and the writer looking over his shoulder at every step, to lay out the photographs in a way that would draw a reader into the experience of the essay.

When Will McBride finished an assignment for *Twen,* on the other hand, he would return the exposed film to art director Willy Fleckhaus with little or no pre-editing. One of his major grievances against periodicals is that so often—at *Twen, Quick,* and others—the record of his experiences became subject at a crucial point to the decisions of another person. The jeopardy here, he feels, is the possibility of misinterpretations and mis-

applications, no matter how deeply he respects the talents of a friend like Fleckhaus.

One layout that does please McBride, of course, is the one he did himself for the *Zoom* magazine version of *Siddhartha* (pages 60-62).

The role of the art director at a magazine depends greatly on the structure of the organization and the personality and strengths of the people in the editorial hierarchy. At a publication run by a strong, picture-knowledgeable editor, the art director might be little more than a competent designer who works with photographs selected for him. In other publications, the system might be more democratic, with assignments and final selections being made—as at *Look*—after those involved had voiced their opinions.

Regardless of power, the final responsibility for the appearance of a book or magazine, and the design of each page within it, belongs to the art director. That responsibility cannot help affecting the layout of an individual essay by any photographer who wants to be published—either by causing conflict, if the photographer's ideas clash violently with the art director's, or by bringing on a collaboration that might or might not improve the essay.

An amateur photographer who wants to assemble pictures into essays, in an album or a scrapbook, can pick up a number of useful ideas by studying layouts in the major magazines of today and yesterday.

In Aguascalientes, Fusco photographed the aftermath of a bullfight for an essay on Mexico. For the photograph on pages 82-83, he panned a 180mm lens with the victim of the fight as mules dragged it away.

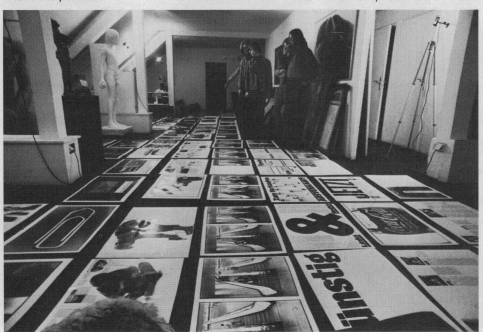

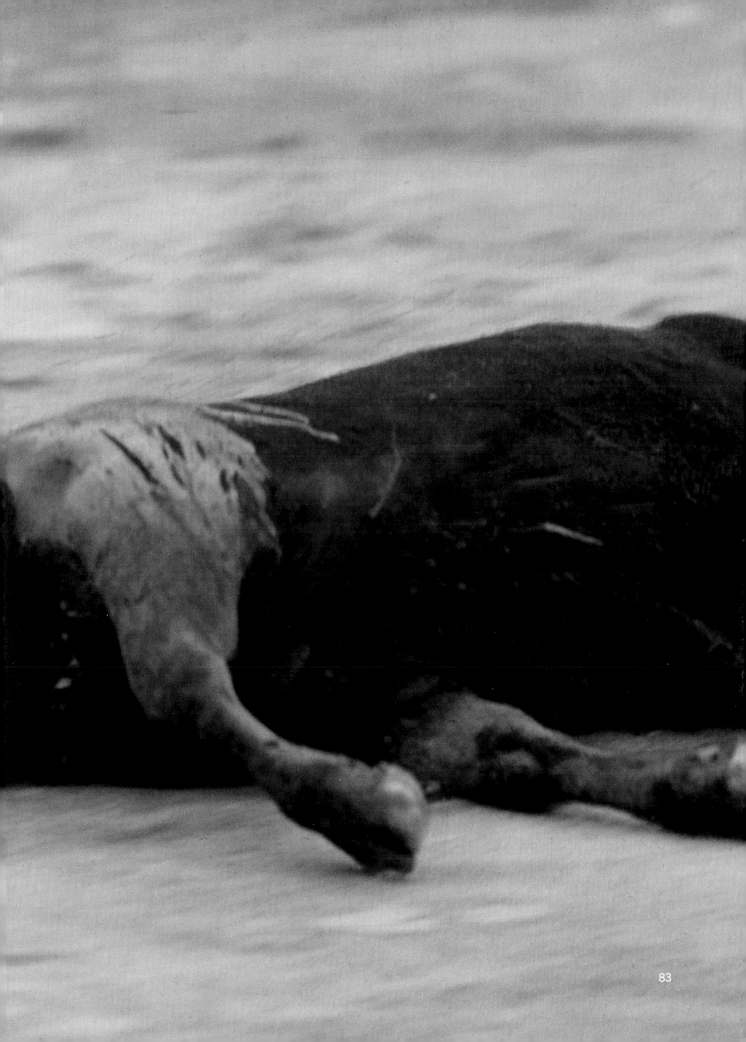

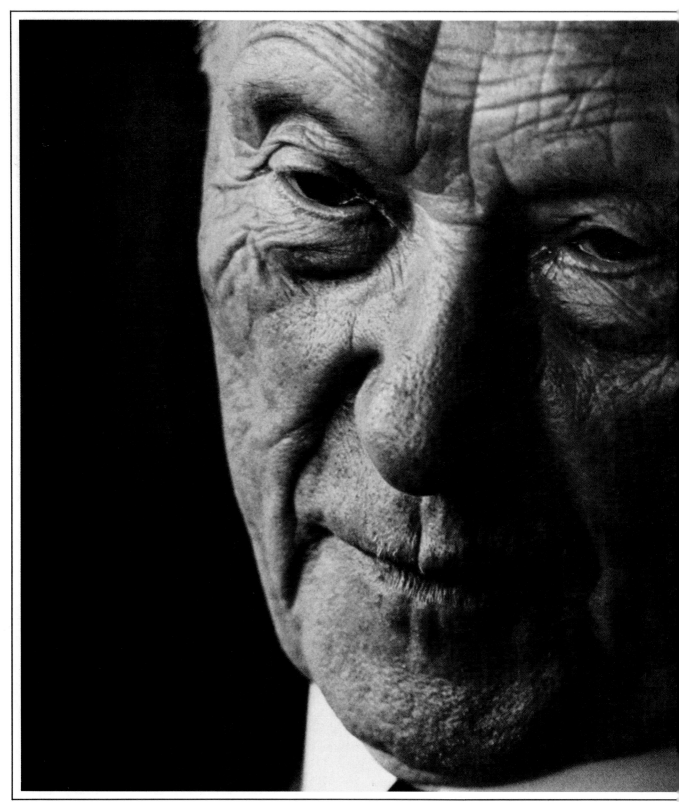

Portraying a theme through a person

We have seen Will McBride manipulate people and scenes to illustrate a reality that begins in his own dreams. Of all his essays, there is only one that he shot without directing the movements of his subject —the book *Adenauer, A Portrait.*

Germany's chancellor was almost 80 years old when McBride arrived in Würzburg as an Army lieutenant. That autumn, Adenauer's face was everywhere on election posters, McBride remembers, "part of the landscape, like the withered apples on the Bavarian trees." McBride knew Adenauer had been re-elected and that he looked old, but that was all he cared to know. His attitude changed

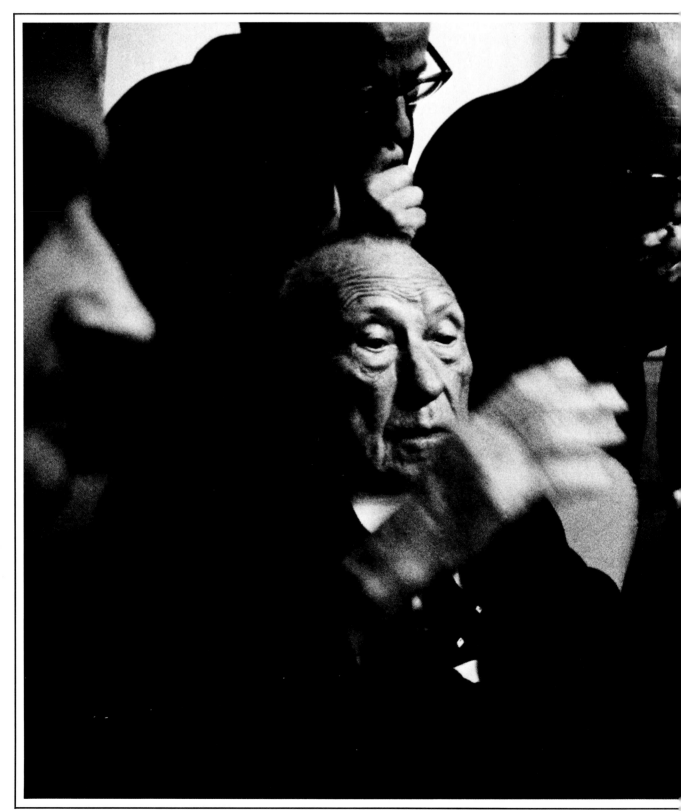

when he met Adenauer in 1960. *Quick* had assigned him to photograph the chancellor—a standard behind-the-scenes look at the country's leading politician—and the two had their first encounter while Adenauer vacationed in Italy. Words flowed from the man in torrents, his thoughts lucid and direct, a deep energy booming into each phrase. For four and a half hours he talked with a reporter. As he did, McBride worked around him with black-and-white film in a Leica M3, one of the workhorse rangefinder cameras for photojournalism.

They became friends.

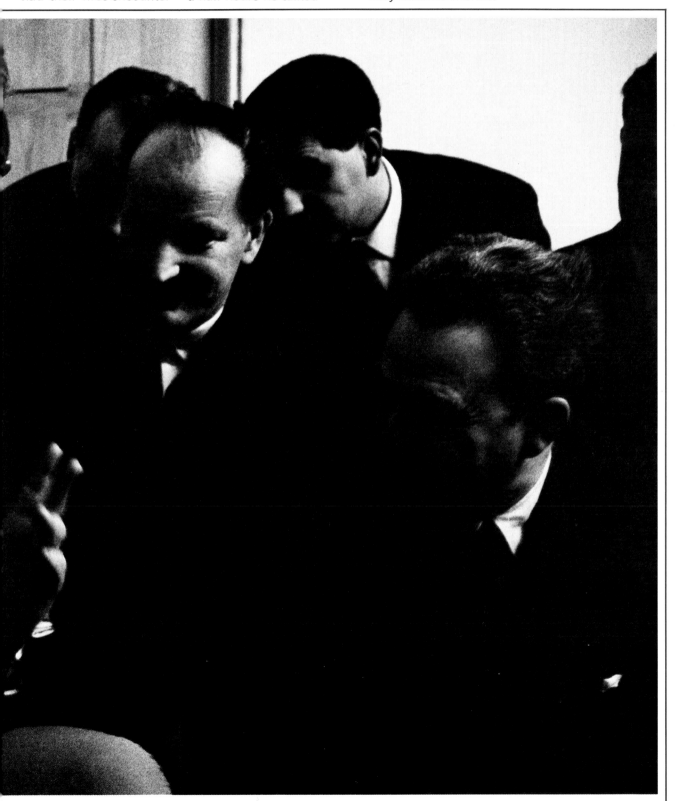

Knowing that, editors kept assigning McBride to Adenauer stories. When McBride decided at one point that he wanted to do an essay on aging, he sensed that the deep coverage he was accumulating on Adenauer would be an ideal vehicle for it. Meshing the two projects over six years, he carefully maintained a consistent approach through all his different Adenauer assignments: Tri-X film for both indoor and outdoor shooting, rangefinder cameras with wide-angle lenses and a medium-length 85mm lens.

McBride spent the day of Adenauer's retirement with him in 1963. As he had throughout his coverage, he frequently used side lighting to emphasize the texture of Aden-

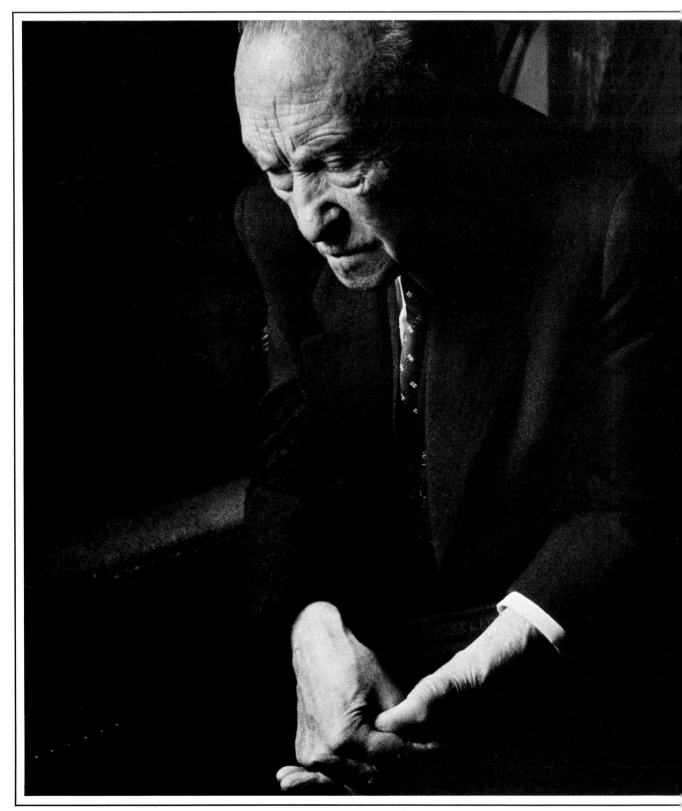

auer's features, showing a man both rugged and vulnerable as he met with reporters for a farewell party (pages 86-87), walked through his garden south of Bonn (pages 88-89), and sat alone at last.

In 1965, two years before Adenauer's death, McBride's book-length portrait was published. The flow of its black-and-white images revealed not only a photojournalist's skill, but also a young man's admiration for the power of age. McBride puts it simply: "Almost every picture I take is of a person I like, a person I can identify with."

Just as McBride can abandon manipulation to make an essay of candid photographs, Paul Fusco can turn from his own working habits to direct a series of illustrations for a show-business personality story.

His challenge in photographing singer Diana Ross was a familiar one. Well-known performers are already shaped in the public mind as ready-made images; their

careers have brought them before so many cameras that the task of any photographer is to find an approach that has not been made trite by his predecessors. How could Fusco get a look at the star that would remain true while conveying something new?

To begin, he shot her in five separate performances at the Waldorf in New York. Her style is dynamic, electric; she moves constantly, almost feverishly. As she prowled across the stage, Fusco crouched behind a tripod at the far end of the room and watched through a 300mm lens mounted on a Nikon. Using high-speed Type B Ektachrome film, he bracketed exposures from one to three seconds. He opened the shutter; when half the exposure had elapsed, he swung the camera to the

left, streaking the image already recorded at the right side of the frame.

That was one impression. Fusco wanted more, something with crisper definition that would still project the singer's energy through a photograph that obviously could not use the main vehicle of that energy, her voice. Over the years he has photographed dozens of entertainers—Leonard Bernstein, Joan Baez, Marlene Dietrich, Jason Robards, Dustin Hoffman, Natalie Wood, Alice Cooper, Steve Allen—but this approach to Diana Ross was new for him.

"We were not trying to get at her innermost self," he says. "We were doing a dramatic presentation of a really dynamic human being who has an incredible amount of charisma and electricity as a performer. We were trying to transmit the dynamics of a show person, rather than trying to get across the personal Diana Ross."

Fusco decided to recreate her energy in a studio, and followed her to Los Angeles. He called

94

in a body-painter who covered her with bright designs; he piped music into the studio; then he told her to let go, sing and be herself.

He had set up a black background of seamless paper. In front of it, a silver umbrella six feet across was set up to diffuse the light of a single large strobe over a wide area so that she could move wherever the spirit took her and still be in range.

In the quieter portrait on page 92, Fusco looked for yet a third mood to round out his impression of the performer. To convey sultry, pent-up excitement, he lighted her at almost a 90-degree angle, emphasizing the texture of her skin while leaving the eyes cloaked in shadow. He preserved minute detail by working extremely close to Ross' face with a 55mm Macro-Nikkor lens.

Although he admits it is effective, such manipulation is not Fusco's favorite way to work. "The best thing in the world for me," he says a bit wistfully, "would be to be invisible. I'd like to have no influence on what I'm looking at—just to be there studying and looking and reacting, being allowed to pick out those moments. But the best I can do is to become so assimilated in people's lives, as I hope I did in stories like George's Branch and *La Causa,* that I do become invisible for all practical purposes.

"There is no way of knowing. I will never know how much of what I'm looking at has been influenced by me or by my camera. But my intent is to reduce that influence as much as I possibly can, so I can feel confident that what I'm looking at is real and true for the people in the pictures, and that my presence is not what's making it happen."

The versatility of essayists like Fusco and McBride has something to do, of course, with their command of technique; they know how to use light and equipment to clarify vision. Beyond mechanics and beyond their approach to any individual picture, however, their power resides in an ability to organize images in ways that speak forcefully to a wide audience while keeping faith with the subject. McBride speaks through the people he photographs; the people Fusco photographs speak through him; other essayists speak in other ways.

The photo essay remains an intensely personal photographic form for just this reason: It calls upon the photographer to stand behind every judgment. The photographer chooses to tell a particular story, to tell it in a certain way that bares its strengths and weaknesses. No matter how he approaches his story, how he chooses to tell it, his essay is his own truth.

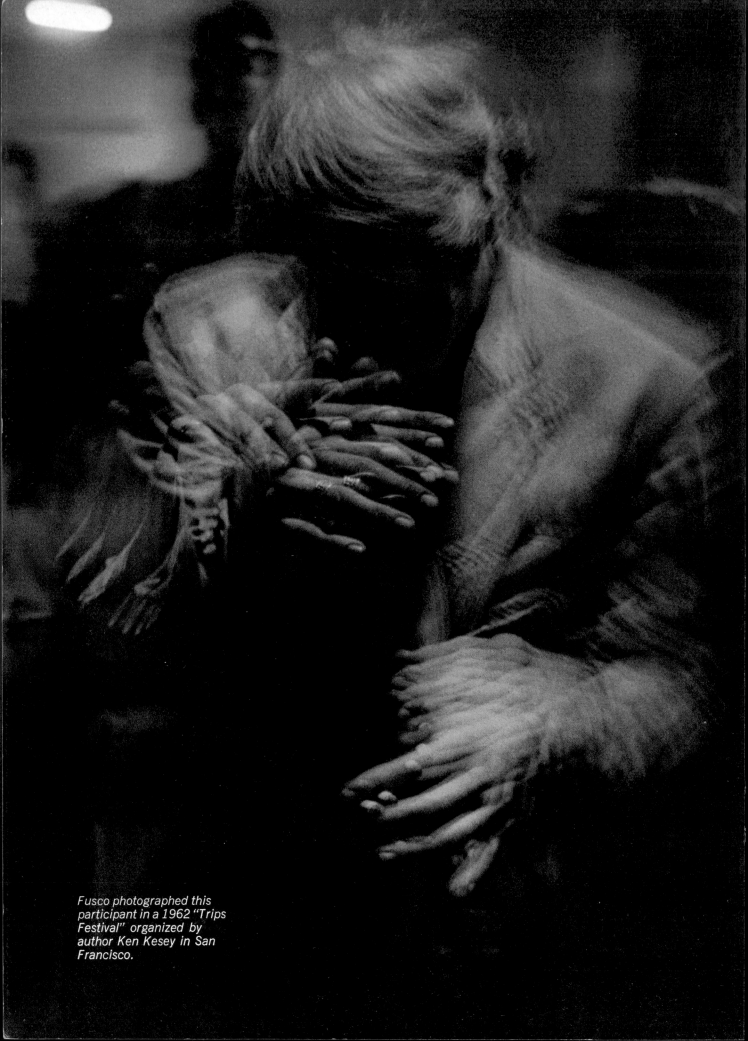

Fusco photographed this
participant in a 1962 "Trips
Festival" organized by
author Ken Kesey in San
Francisco.